ANYONE CAN PAINT

COASTAL LANDSCAPES

Originally published in 2020 as *The Paint Pad Artist: Coastal Landscapes*
This edition published in 2024
Search Press Limited
Wellwood, North Farm Road,
Tunbridge Wells, Kent TN2 3DR

Text copyright © Charles Evans, 2020, 2024

Photographs by Roddy Paine Photographic Studios

Photographs and design copyright © Search Press Limited, 2020, 2024

ISBN: 978-1-80092-149-8
ebook ISBN: 978-1-80093-136-7

The Publishers and author can accept no responsibility for any consequences arising from the information, advice or instructions given in this publication.

Suppliers
If you have any difficulty obtaining any of the materials and equipment mentioned in this book, please visit the Search Press website: www.searchpress.com

Extra copies of the outlines are available from www.bookmarkedhub.com

You are invited to visit the author's website: www.charlesevansart.com

Publishers' note
All the step-by-step photographs in this book feature the author, Charles Evans, demonstrating how to paint coastal landscapes. No models have been used.

Acknowledgements

I would like to thank Daler-Rowney for its continued support and supply of, what I consider to be, the best art materials in the world. Also, great thanks to Beth, my editor at Search Press, for her diligence whilst trying to understand what I'm saying.

Dedication

This book is dedicated to Gail for her tireless efforts in keeping me on the straight and narrow. One day she will succeed!

ANYONE CAN PAINT
COASTAL
LANDSCAPES

EASY STEP-BY-STEP PROJECTS TO GET YOU STARTED

Charles Evans

SEARCH PRESS

CONTENTS

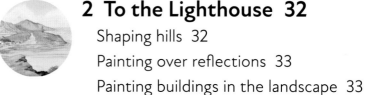

INTRODUCTION

Watercolour has a reputation as a particularly difficult medium to master; yet when someone takes up painting, they first turn their hand to it. Very soon they come across the complexities and difficulties of watercolour, which can very quickly invite the artist's fear of the medium. Within the pages of this book, I intend to demystify watercolour techniques and dispel some long-held myths.

The most common place for new artists to start is with landscapes, as they seem to be the easiest subject: there are no complex buildings or people to paint in – and after all, how difficult can a field be? In this book, however, I will show you how to paint increasingly complex landscapes with the added bonus of coastal details. As you progress through the book you will find you become confident enough to include all the elements that enhance a landscape – buildings, trees, shadows and light.

As a newcomer to painting, you may also be put off by the prospect of having to make an initial drawing, but don't worry – I have already done this for you. You can trace the outlines provided at the back of the book onto watercolour paper, and jump right in.

I use only four brushes and a limited palette of colours within a painting so you will not be overwhelmed by a wealth of materials. I'll also be addressing some confusion over gouache – you may not yet know what it can be used for but I encourage you to think of it as an opaque watercolour. This means that you can use gouache to put areas of light on top of dark.

Without further ado, while I should say, 'Let's get down to some serious painting,' what I mean is, 'Let's slap some paint on the paper, get our hands dirty and have some fun while we learn'!

HOW TO USE THIS BOOK

HOW TO CHOOSE WATERCOLOUR PAPER

The watercolour paper that I use has a lovely textured surface and doesn't require any pre-stretching or preparation. I recommend that you use a similar, Rough watercolour paper for the best results. Take a tracing of the outline (see below) so that you can reuse the drawing several times. Remember: practice makes perfect.

TRACING THE OUTLINE

You can of course paint directly onto watercolour paper, following the step-by-step instructions. However, if you are less confident, or if you later wish to paint variations of any of the projects, I recommend that you make tracings of the painting outline before you commit paint to paper. The outlines can be found at the back of the book, on pages 98–103.

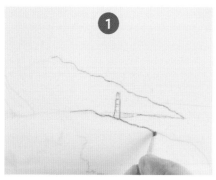

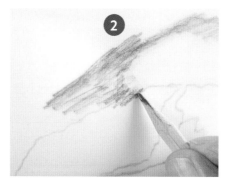

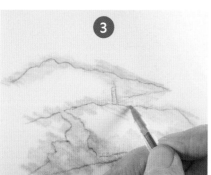

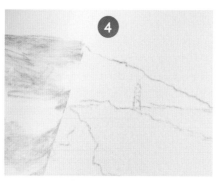

1 Lay a sheet of tracing paper over the outline. Trace the outline of the painting with a pencil.

2 Turn the tracing paper over and shade over the tracing.

3 Turn it back over and place the tracing on a clean sheet of watercolour paper. Go over the outline with a ballpoint pen; check that the outline has transferred onto the watercolour paper.

4 Lift the tracing paper to reveal the impression on the paper.

SECURING YOUR PAPER

Like many artists, I use masking tape to secure my watercolour paper. However, rather than putting a piece of tape on each corner of the paper, to hold it still, it's much better to tape all the way around all four sides. This way, when you have finished the painting, you will get a nice, sharp edge all the way around, which shows the finished picture to its greatest effect.

If you have taped at the corners only, and you are using a large brush to lay in a sky wash, working from side to side, droplets of water that have become trapped underneath the paper will seep out and result in a 'cauliflower' (see page 24) along the edge of the sky. That's why it's much better to seal off your paper edges completely.

REMOVING THE TAPE FROM YOUR PAINTING

When you remove the masking tape from your finished painting it is important to tear it away from the paper. Exaggerate the movement, tearing very deliberately, so that if the tape starts to tear the paper, it won't take any of the actual painting away with it.

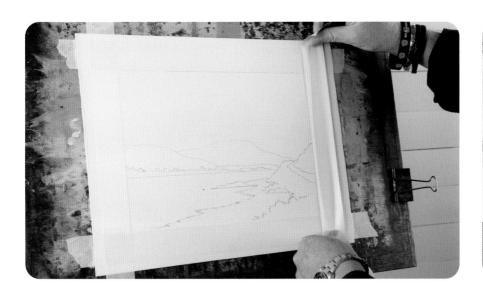

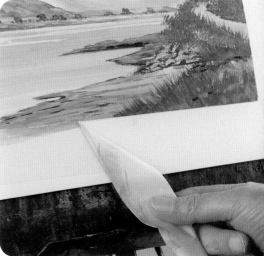

WORKING THROUGH THE BOOK

I have deliberately planned the projects in this book so that each project gets slightly more difficult as you travel through the pages. Within each project, there are more, differing techniques to learn. It's up to you whether you work through the projects in the order in which they appear in the book, or just pick one that appeals to you. This is your book, after all!

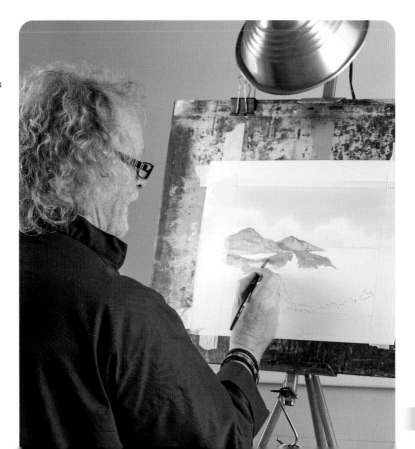

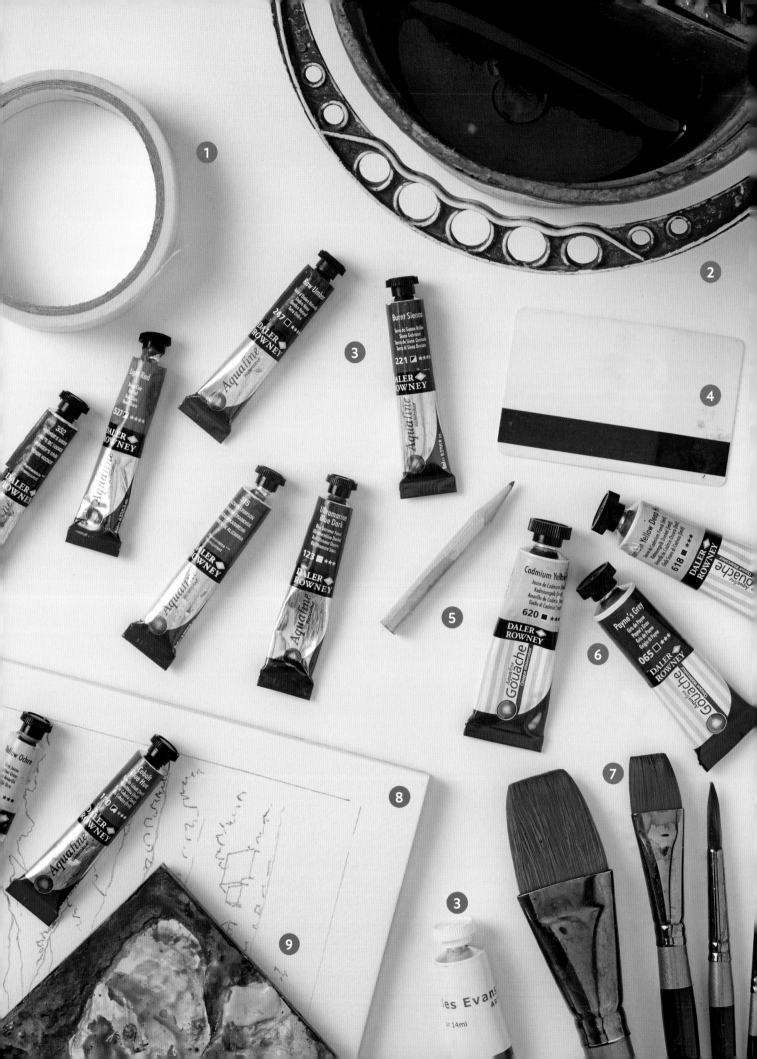

WHAT YOU NEED

I use very few colours and very few brushes, and I only use brushes of classic shapes and sizes. My choice of watercolour paper is always the same. Keeping things simple will make your painting kit transportable, especially for those outdoor painting trips. It also means that you get more proficient more quickly as you don't have to make too many choices.

1 Masking tape

There are lots of opinions on masking tape and whether it's best to use high-tack or low-tack: but I don't think it matters. I use any type but prefer wide tape rather than narrow. No matter what masking tape you use, make sure that you tear it off in the way that I've shown you in this book (see page 9)!

2 Water bucket

The water bucket that I use is split into two sections so that you can have clean water on one side and dirty on the other. It has to be said that both of my sides are normally dirty. If you are working from a table, the handle also serves as a brush holder due to all the holes. I use the handle to hook the bucket onto my easel as I tend to stand up to paint.

3 Paints

For this book, I have used Daler-Rowney Aquafine paints which, strictly speaking, are students' quality paints. In the past, students' quality paints were nowhere near artists' quality paints; this has changed quite a lot over the last couple of years. When Daler-Rowney reformulated its vast Aquafine range, the company introduced natural pigment into students' quality paint, making them much closer in quality to artists' paints.

4 Plastic card

I use a plastic card for scraping out rocks, stones, bricks and cliff faces, especially when I want these things to be more prominent in the landscape. It is also really useful for scraping out a sailboat or two in the distance. I use one of the many room cards from the hotels I stay in most nights of the week. Driving 40,000 miles a year as I do, you do tend to accumulate a lot of hotel cards, so I am never short!

5 Pencil

From a well-known household store. I tend to use any pencil I can get my hands on as I am never going to do cross-hatching or shading in my drawing; it is only ever used for a simple outline. Having said that, Daler-Rowney/Lira make fabulous pencils that have been around for a great number of years.

6 Gouache

Gouache is a really good rescue remedy. It is good for painting in its own right, but if you want to add light to something afterwards, you can also paint over watercolour with gouache as I've done in this book, adding light grasses to the tops of hillsides. It is opaque and therefore will cover any small mistakes made in watercolour.

7 Brushes

I use at most four brushes: again, these are Aquafine brushes by Daler-Rowney. They are so hard-wearing, and I really abuse my brushes, as you will see within these pages! Nevertheless, they keep their shape and always spring back. They are synthetic brushes that hold almost as much water as sable brushes do. I also use the same set of brushes for my acrylics: if you wash them out enough, they won't get clogged up with acrylic paint. The brushes shown here are a 30mm (1¼in) flat wash brush, a 19mm (¾in) flat wash brush, a size 8 round brush and a size 4 rigger brush. The size 8 round brush has a fine point, which makes it ideal for detail work, but can equally be splayed and used for stippling. That same brush will regain its fine point the moment it is washed.

8 Outlines

The outlines provided at the back of the book are based upon my own drawings. I hope that these outlines will spur you on to create your own coastal landscapes, but you will certainly get the idea of how to create a little bit of recession in your paintings from these outlines.

9 Palette

The palette is a mucky old thing, and many people ask me how I manage to get such lovely, clean colours from it. I've no idea, really, but it works! Although it is a mess, it's a fairly organized mess: all of the colours are squeezed out in the same places time after time, and all the various mixes are always done in the same areas. For instance, blues, greys and blacks are all mixed underneath the area where the blues are squeezed out. Likewise, all the greens are mixed directly beneath where the Hooker's green is squeezed out; similarly the browns and the yellows.

GENERAL TECHNIQUES

SETTING UP YOUR EASEL

I prefer a metal easel, as it is sturdy and lightweight, ideal for outdoor work. I always turn it upside down when setting it up, so that I can see that I am pulling out each extendable leg to the exact same length. Then when I put it the right way up, it's going to be perfectly straight and level.

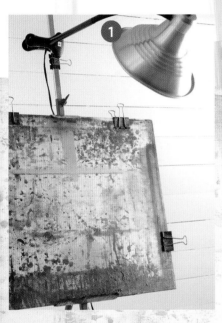

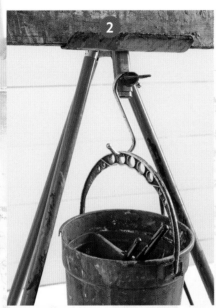

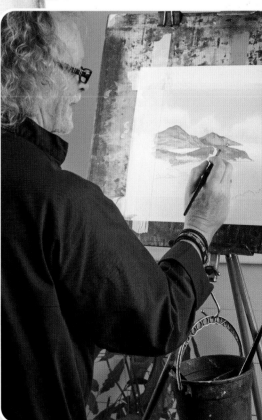

1 If I'm painting indoors, I like a light above my easel with a daylight bulb in it. I also clip a bulldog clip onto my easel to stop the light sliding down.

2 Once I have filled my bucket with water, I use an S-shaped hook to hang the bucket onto the easel so there is a bit of a gap between the water and the easel. This stops me accidentally catching and knocking the board holder at the base of the easel.

WORKING WITH WATERCOLOUR

One of the most common things that I hear on my travels from people painting watercolours is that they always struggle to know how much water to put in. It's simple: the stronger you want the colour, the less water you put in. If you want a very weak wash, add a lot of water; for a strong colour, put in a single brush-worth of water.

Water + colour

Never use watercolours by themselves: always mix them with water! It seems like a very obvious thing to point out but it's equally very important. The amount of water you mix in with your watercolour will determine the hue and the strength of the colour on the paper.

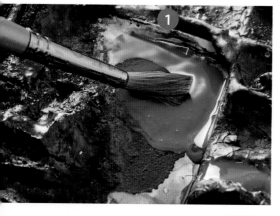

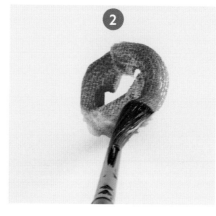

1 In my palette, the same colours are squeezed into the same places every time and the same variation of colour mixes are mixed in the same wells every time. Because of this, and even though my palette looks a real mess, I never get 'mud' – my colours are always clean.

2 Once I've prepared the mix in the palette, it is at this stage that I determine how much water I put into each mix before applying it to the paper. You'll see this as I work through each individual painting.

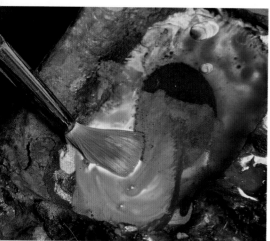

COLOURS AND MIXES

I use very few colours, and always squeeze these out of tubes of paint. If the colours dry out in the palette, I can reactivate them simply by stroking over them with a wet brush.

I carry only two blues in my palette: ultramarine blue and cobalt blue, which are each suitable for skies, and can be mixed with Hooker's green and burnt sienna for a sea mix.

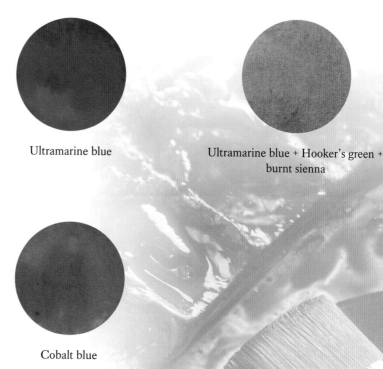

Ultramarine blue

Ultramarine blue + Hooker's green + burnt sienna

Cobalt blue

Yellow ochre

Burnt sienna

Alizarin crimson

Light red

It is important to note that light red is not a red made lighter: it's amazing how many people use cadmium red and put lots of water into it thinking they've made light red. They haven't: they've made cadmium red lighter. Light red is a specific colour more akin to burnt sienna (see above).

Light red is a mild shade in the palette and vivid on paper so be careful how strong you make it and be wary of how much water you put in.

Light red

Light red + ultramarine blue

Raw umber

Raw umber, which is used quite extensively in the *By the Lake* painting (pages 20–31), is the only brown I use. It is a nice, standalone brown and is also very versatile especially in a mix – put a touch of cobalt blue into your raw umber and you have a sepia tone that is well suited to a landscape.

Raw umber

Raw umber + cobalt blue

Hooker's green

Hooker's green has a slightly questionable reputation among landscape artists. Many do not like it as it is a very strong, unnatural green. My solution, therefore, is to avoid using Hooker's green by itself – mix Hooker's green with a blue from your palette, such as cobalt blue, for a more unassuming green.

Hooker's green

Hooker's green + cobalt blue

Sand (Charles Evans Sand)

Sand is a particularly useful colour. It is particularly good for layering colour: put down a wash of Sand and run other colours over the top. The Sand will still shine through. It is also useful as a lightener: a touch of Sand added to any colour you use will lighten it fractionally.

Sand

Sand + yellow ochre

Black mixes

I don't use a manufactured black – I recommend always mixing a black to avoid the colour looking flat. My most frequently-used black is a mix of blue (depending on the blue of the sky) and burnt sienna in equal quantities. Another mix I use, less frequently, comprises Hooker's green and alizarin crimson.

Ultramarine blue +
burnt sienna

Hooker's green +
alizarin crimson

Shadow mixes

As I've always said, don't change your blue throughout a picture – not for anything natural anyway. My shadow mixes always comprise the blue of the sky plus alizarin crimson and burnt sienna. You are making a purple, then toning it down with the burnt sienna – you are aiming for a dark aubergine colour.

Sometimes you will need to paint in a dark shadow near the foreground and, as you work further back in the painting, a milder, weaker shadow; the alizarin crimson in the mix will help you retain warmth in the shadow no matter how distant it is.

Be brave with these mixes – a dark shadow will actually bring out the light in your picture.

Ultramarine blue, alizarin
crimson + burnt sienna

Cobalt blue, alizarin crimson
+ burnt sienna

INTEGRATING GOUACHE

Gouache is a great painting medium for beginners as it can be used to cover and highlight details in a landscape. If you want extra light brought into the painting, you don't always need to plan where it will fall – put it in with gouache after the watercolour has been laid. I have used three gouache colours in this book: cadmium yellow deep, cadmium yellow hue and Payne's grey.

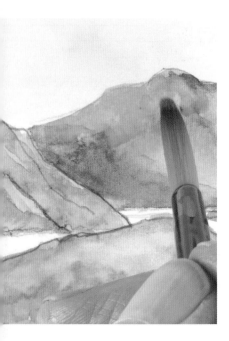

Cadmium yellow deep

Cadmium yellow hue

Payne's grey

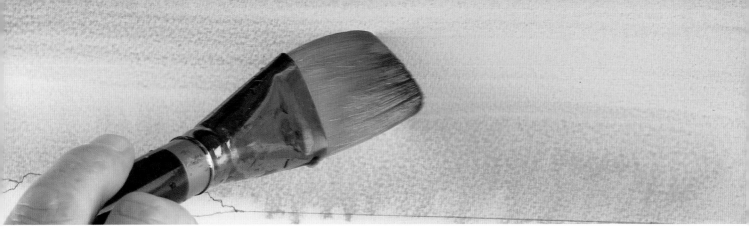

LAYING A WASH

I tend to use one of two types of wash in a painting, especially for sky washes. I use either a flat wash, where the colour stays the same in depth and strength, or a graduated wash, where the colour starts off stronger at the top, gradually getting weaker as it comes down the paper.

With either of these washes, I always prewet the whole paint area with clean water. Importantly, when working with prewet paper, always make sure all the paint is on while still good and wet, otherwise you run the risk of getting water marks or 'cauliflowers' (see page 24).

Flat wash

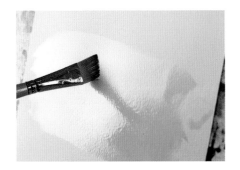

1 Begin by prewetting the paper with a flat wash brush and clean water.

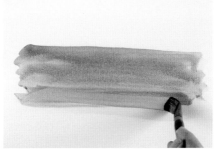

2 Go over the wet paper with a single colour (here, ultramarine blue), keeping the paint the same depth all the way through, from top to bottom.

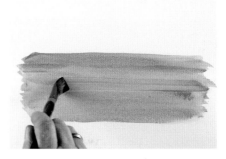

3 Go back up to make sure all the paint is evenly spread.

Graduated wash

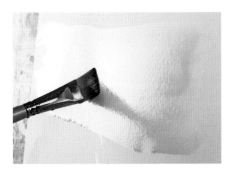

1 As with the flat wash, prewet the paper with the flat wash brush.

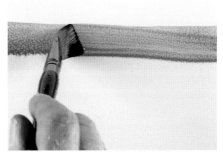

2 Start the wash at the top of the paper, and keep the colour strong.

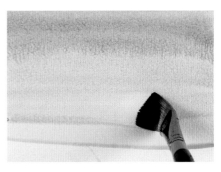

3 Add a little more water to the brush and make sure the wash gets weaker as you move down.

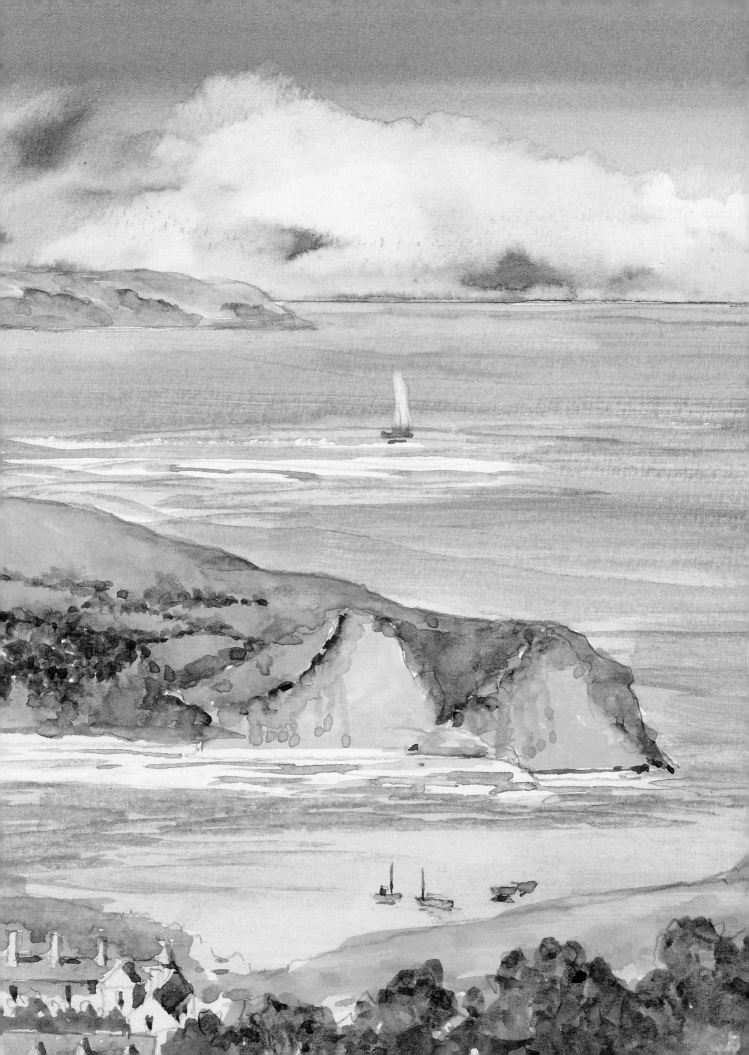

THE PROJECTS

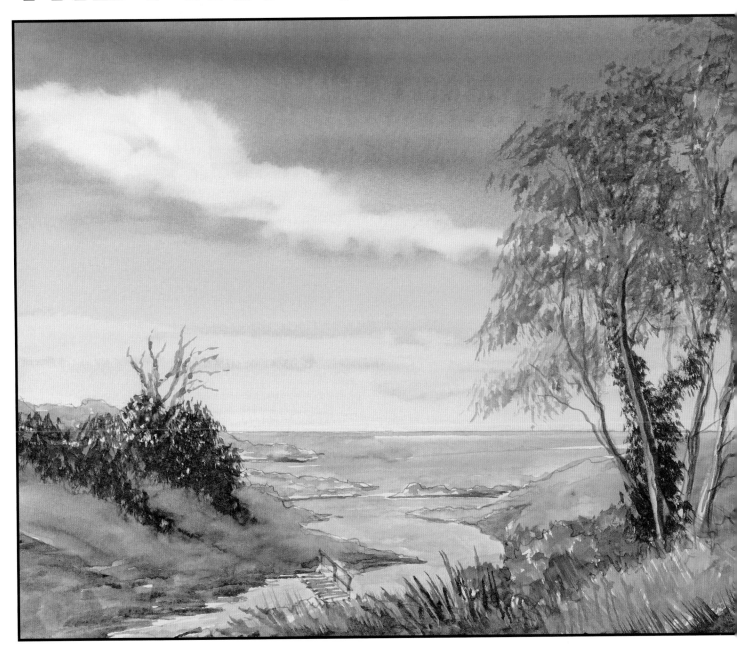

1. BY THE LAKE

This is a lovely, open landscape with gentle hills; the sea merges with the lake to give a feeling of isolation and remoteness.

BEFORE YOU START

YOU WILL NEED
30mm (1½in) flat wash brush, 19mm (¾in) flat wash brush, size 8 round brush, plastic card, outline 1 (see page 98)

COLOURS NEEDED
Yellow ochre, ultramarine blue, burnt sienna, raw umber, light red, Hooker's green

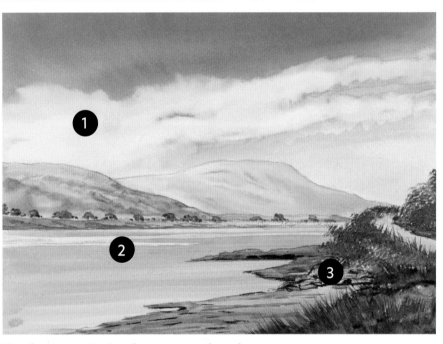

Technique 1: Sucking out clouds

Creating clouds in the sky is a very simple technique. To depict the softness of clouds, however, this technique needs to be applied while the sky is still good and wet. Prewet the sky before laying your sky wash and lift – or suck – out the clouds.

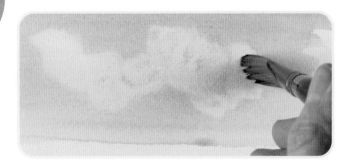

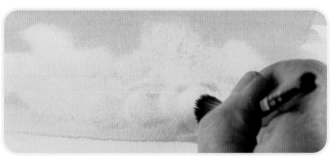

1 Make sure your brush is clean and damp. Work across the paper in a swirling motion, using the side of the bristles to remove the colour of the sky, leaving the shapes of the clouds.

2 Continue the swirling motion until you are happy with your cloud coverage. Do be careful not to push the metal, or ferrule, of your brush into the paper as it will spoil the surface.

Technique 2: Scraping out rocks with a plastic card

Sometimes an unusual tool can be used to give a very convincing painterly effect. I discovered that a plastic card (such as a hotel room key!) can produce effective rocks. You do not need to use the exact colours that I've used below – try using Sand, with a touch of cobalt blue on top. This effect is also excellent for suggesting stonework on an old building.

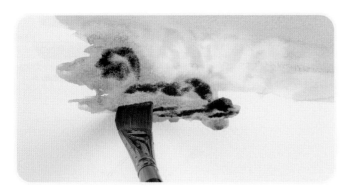

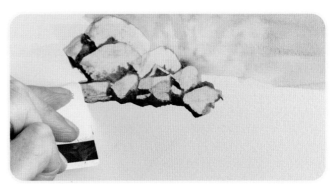

1 Paint in the rock area first, in yellow ochre with a dark mix of raw umber, ultramarine and burnt sienna over the top, wet-into-wet.

2 Hold the flat edge of the card against the still-wet paint and pull it across the area, bending the card slightly. Leave gaps between the scrapes – this will allow the wet paint to gather in the gaps and give shadows between the rocks.

Technique 3: Putting in grasses

The effect of a clump of grasses can be attained easily with the 19mm (¾in) flat wash brush. The brand that I use – Daler-Rowney Aquafine – has a nice sharp edge to it.

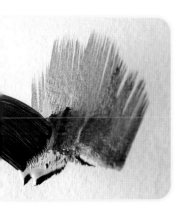
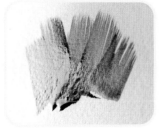

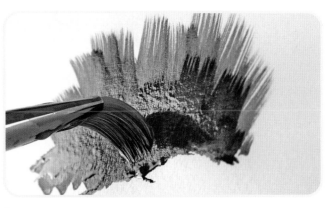

1 Load the brush well – here, I have used a strong mix of Hooker's green and burnt sienna. Press the bristles against the paper so that they bend downwards, then flick the bristles upwards.

2 To add dark shadow areas to your grasses, go over the base of the green grasses with a blue that matches the blue of your sky.

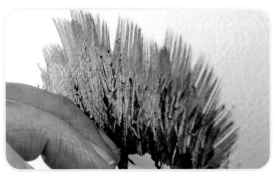

3 Use your fingernails to scratch into the paint and introduce light among the grasses.

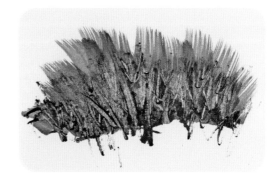

THE PAINTING

1 Make sure the paper is well and truly prewet in the sky area using the 30mm (1½in) flat wash brush.

2 In the bottom part of the sky, pop in a little bit of well-watered yellow ochre, laid in on a slight diagonal.

3 Mix ultramarine blue with a tiny touch of burnt sienna and plenty of water, and run the colour down from the top, all the way into the yellow ochre. Leave a little area of yellow ochre visible at the base of the sky.

4 Wash out your brush and squeeze out the water on the bristles between your fingers.

Charlie's top tip

When laying in a prewet sky wash, remember that the colour will dry nearly 50 per cent lighter.

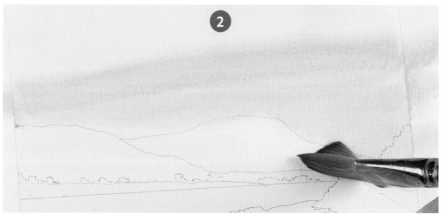

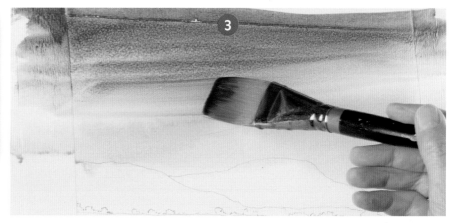

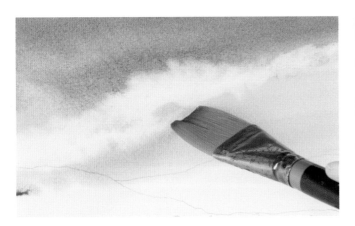

5 Suck out a few clouds, working from the left edge up towards the right-hand corner. Let the sky dry for a short while.

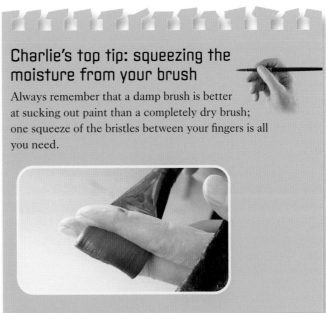

Charlie's top tip: squeezing the moisture from your brush

Always remember that a damp brush is better at sucking out paint than a completely dry brush; one squeeze of the bristles between your fingers is all you need.

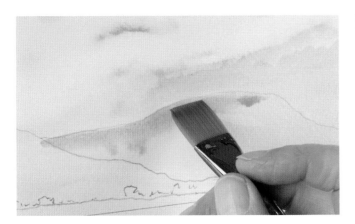

6 Switch to the 19mm (¾in) flat wash brush – you will use this brush for most of the rest of this painting. Prewet the first hill (the largest hill in the centre of the scene). Use less water than for the sky wash – just one brush-worth of water. On the top of the hill, drop in a little yellow ochre – this will be the first of quite a few colours going in to the hill.

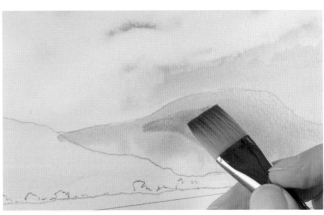

7 Follow the yellow ochre with a little bit of well-watered raw umber. Just drop it on and let it spread among the areas of yellow ochre.

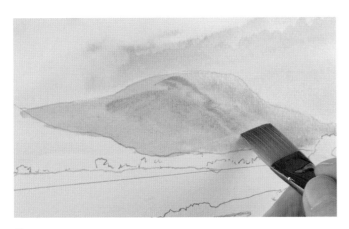

8 Next, drop in a little well-watered light red here and there.

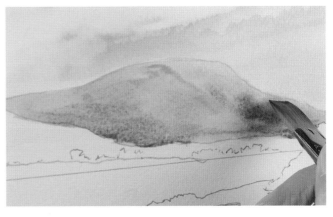

9 Finally, drop in a touch of light red and ultramarine blue, mixed, with plenty of water added. Put in darker areas of shadow but also let the colour spread to suggest the texture and shape of the hill.

Charlie's top tip: correcting 'cauliflowers'

'Cauliflowers' are bleeds of wet colour with ragged edges, which can occur when you are working wet-into-wet and the wet area has already begun to dry as you lay in the next colour.

Many artists think that when a cauliflower occurs in a painting, the picture is ruined and cannot be rectified. Happily this is untrue – you can wash out the cauliflower and work the area again.

Wait until the area in which the cauliflower has occurred has dried completely, then wash out the cauliflower with a damp brush – here, I have used a small flat wash brush. You can then rewet the area and, working quickly, reapply colour wet-into-wet over the top.

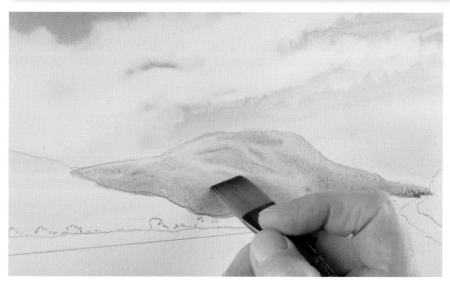

10 Reveal a little bit of light: wash out the brush, squeeze out the moisture with your fingertips and suck out a little paint here and there over the hill.

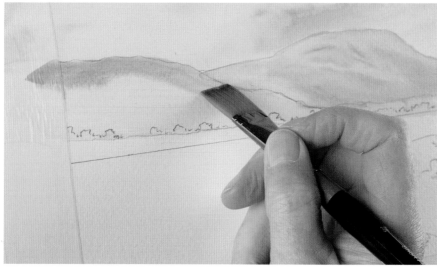

11 Prewet the hill on the left. Lay in the same colours as before, starting with yellow ochre, but slightly stronger this time.

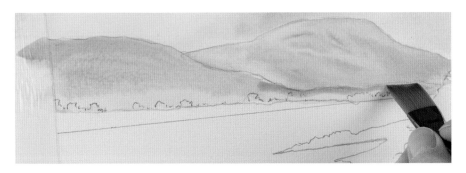

12 Put in a little burnt sienna, well watered, leaving the yellow ochre showing through in places as well.

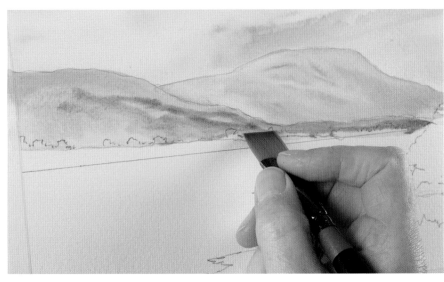

13 Mix raw umber with a touch of light red, and run the colour down towards the base of the hill. This will give you the colour of bracken.

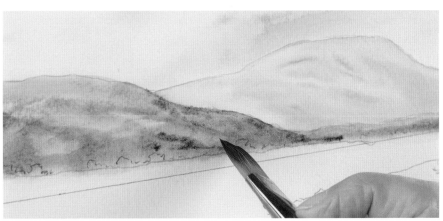

14 Once these colours have merged, run a mix of ultramarine blue and light red down the right-hand side of the hill, just to give a little more depth to the darker areas. This addition of a darker colour will serve to bring the hill further forwards and become more prominent than the now-dry hill in the distance.

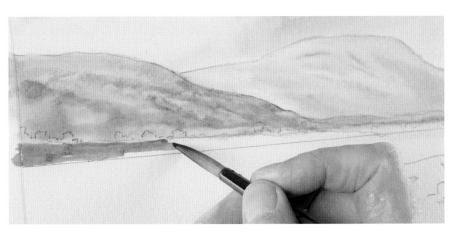

15 Change to the size 8 round brush. With a little bit of raw umber and burnt sienna together, put in the land beneath the hill. Make sure you keep a straight line at the bottom of the hill where the land will meet the water.

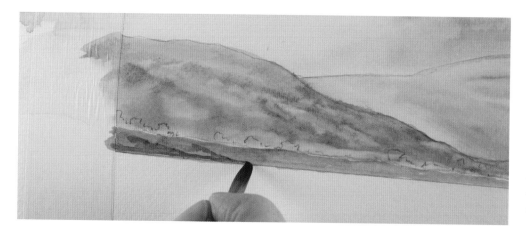

16 Follow this mix with a touch of Hooker's green mixed with burnt sienna. This goes in at the base of the land. Take the colour up into the land here and there, to introduce a hint of green into the brown.

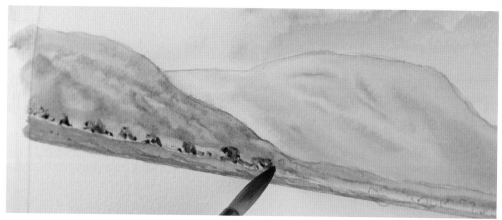

17 Still with Hooker's green but less burnt sienna, dot in the trees on top of the land. Remember that these are a long way off so don't spend time labouring over individual leaves – just dot in a line of blobs running along the land. These will read as trees.

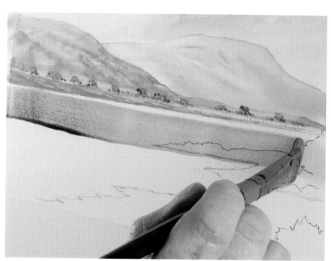

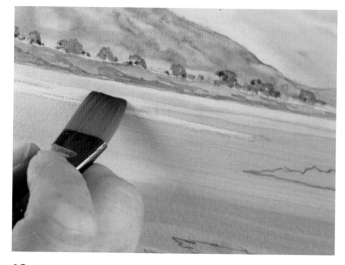

18 Go back to the 19mm (¾in) flat wash brush. Mix in a touch of Hooker's green and plenty of water with the ultramarine blue. Remember that the blue of your water must match the blue of the sky. Working quickly, wet-into-dry, lay broad horizontal strokes over the water to keep it flat.

19 Wash and squeeze out your brush. With the sharp edge of the damp brush, suck out a few touches of light on the surface of the water. Let the water area dry before working on the next area of land.

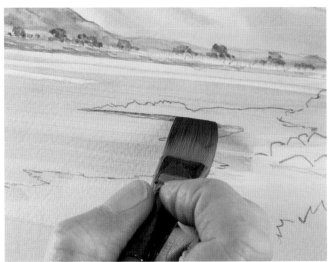

20 Still with the 19mm (¾in) flat wash brush, and a little raw umber mixed with burnt sienna, fill in the little bit of land sticking out into the water.

Charlie's top tip: allowing for light

Notice that I'm leaving the top unpainted at this stage. That's because I am going to drop in a little strong yellow ochre at the top. I will be using just the corner of the flat brush to fill in that area.

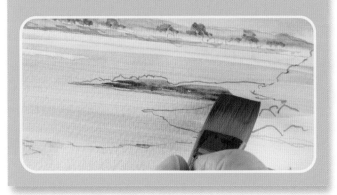

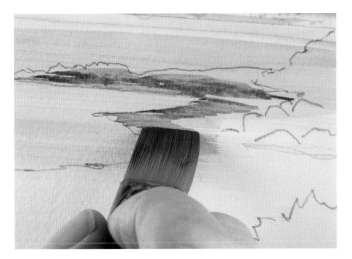

21 Use the very corner of the flat brush to fill in the rest of the land area.

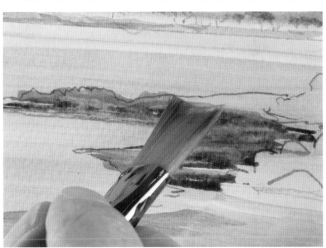

22 Put a few touches of yellow ochre into the foreground land to suggest texture and bumpiness.

23 Mix a little ultramarine blue with burnt sienna for a nice dark, strong colour: go into the base of the land that is touching the water. This will help to 'sit' the land on the water.

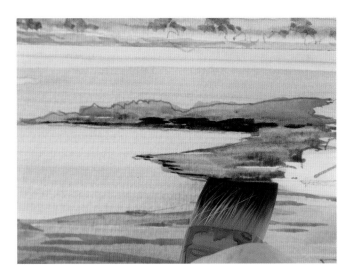

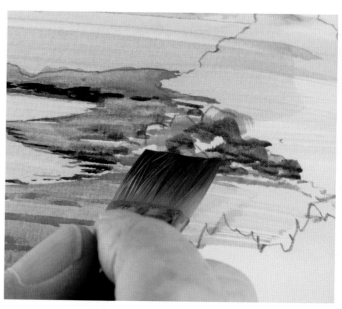

24 Finally, apply yellow ochre, followed by a little raw umber mixed with ultramarine blue very roughly into the same area.

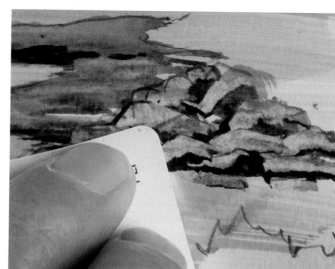

25 Scrape off the damp paint to reveal the shapes of a few rocks using the corner of a plastic card, then leave the area to dry.

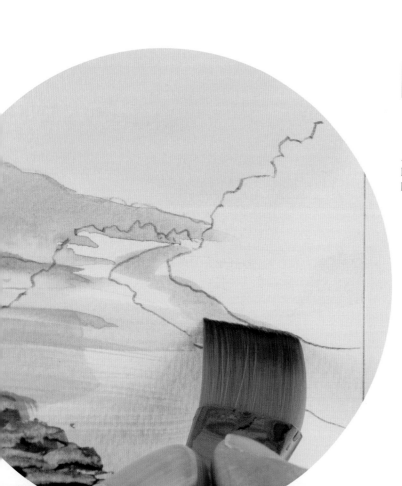

26 Move across the scene to the little path winding around the small hillock on the right-hand side of the painting. Mix ultramarine blue and light red with plenty of water, and fill in the path using the flat brush.

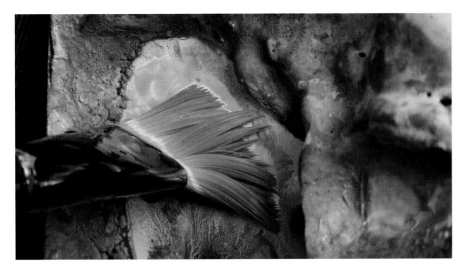

27 Stipple the smaller flat wash brush into the well of yellow ochre in your palette to split the bristles.

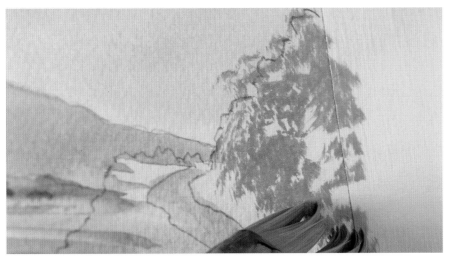

28 Stipple on the foliage on both sides of the path.

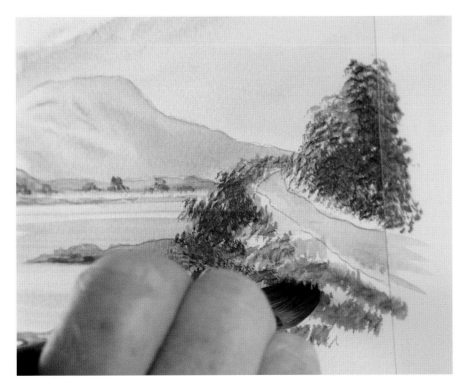

29 Go over the yellow ochre stippling with burnt sienna, then again with a strong mix of Hooker's green and burnt sienna.

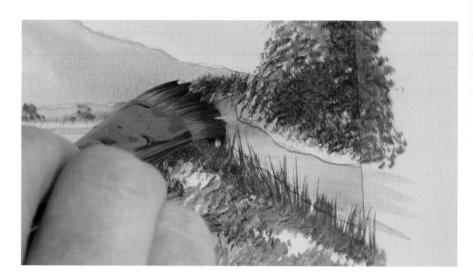

30 Flick up a few individual blades of grass along the left of the path over the top of the stippled foliage areas.

31 Go into the grasses in the foreground with a little ultramarine blue into the Hooker's green–burnt sienna mix.

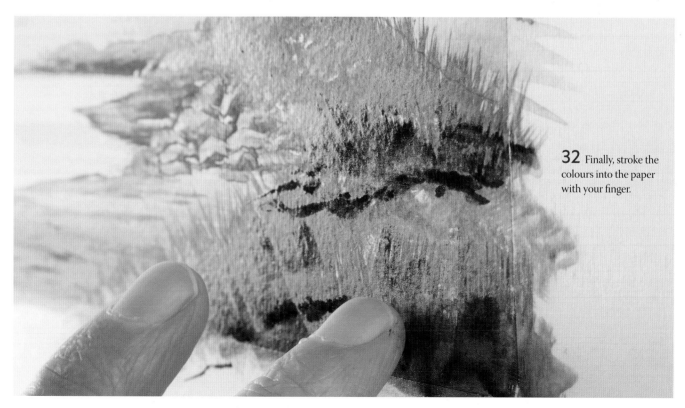

32 Finally, stroke the colours into the paper with your finger.

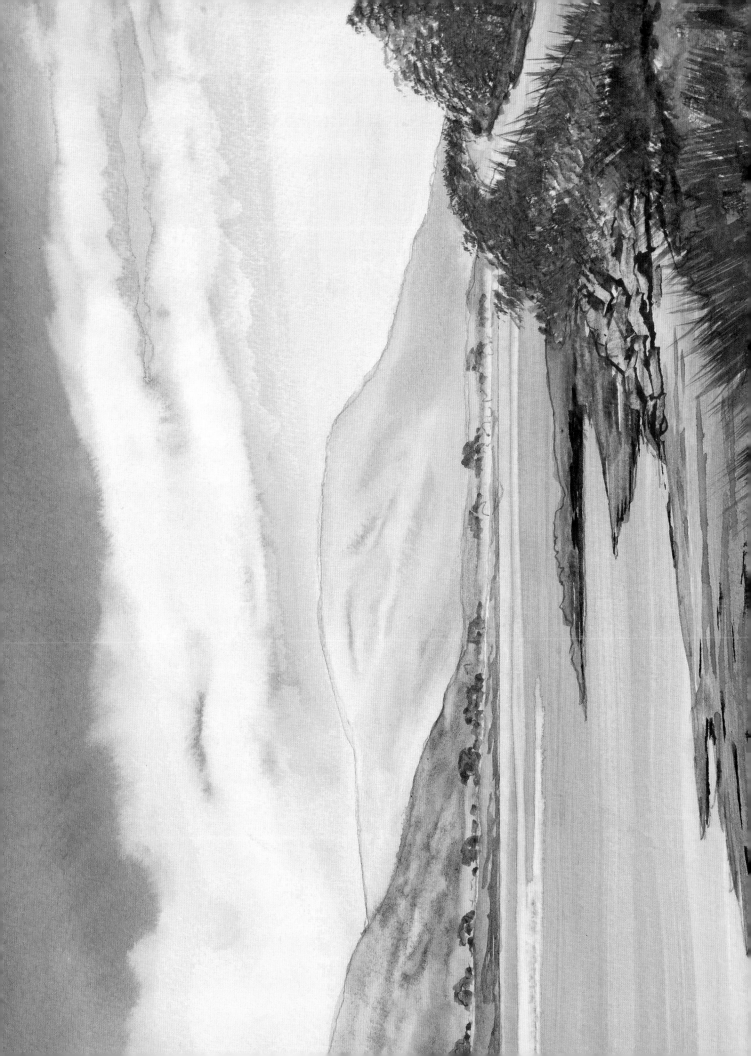

2. TO THE LIGHTHOUSE

This is a glorious, bright scene, which automatically brings to mind a hot country. Keep your colours bright, and don't be afraid of using touches of gouache as it is a saviour of many paintings with its startling colours and vivid freshness.

BEFORE YOU START

YOU WILL NEED
30mm (1½in) flat wash brush, 19mm (¾in) flat wash brush, size 8 round brush, outline 2 (see page 99)

COLOURS NEEDED
Cobalt blue, light red, alizarin crimson, yellow ochre, Hooker's green, burnt sienna, raw umber, cadmium yellow deep gouache, cadmium yellow hue gouache, Payne's grey gouache

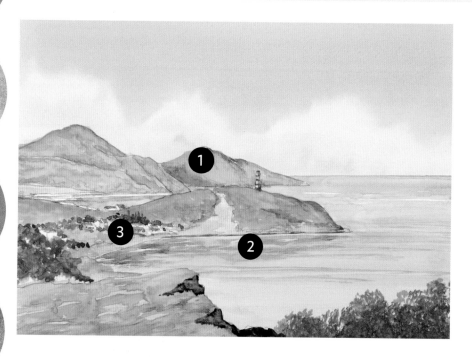

Technique 1: Shaping hills
To make a hill look more realistic, make your brushstrokes count. By this, I mean that you should keep in mind the shape of the hill you want to create, and bring down your brushstrokes in that direction.

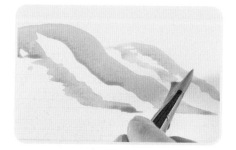

Let your brushstrokes show, and you will instantly shape your hill.

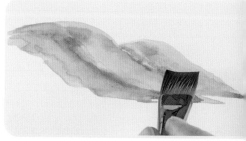

This is just as important when you put in a darker, shadow colour to separate your hills – paint the darker colour in the same direction as the original flow of your hill.

Technique 2: Painting over reflections

When painting over the tops of reflections that you have already laid, it it important to work quickly: don't prevaricate or be scared.

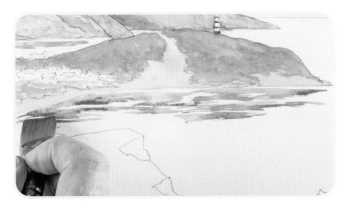

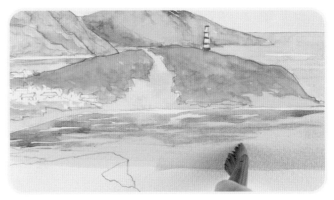

1 Paint in the reflections and leave them to dry completely before you go over with a wash – work wet-into-dry.

2 Brush all the way through the reflections to soften them with water. This will give a far more natural look to reflected water than painting on the reflections over the top.

Technique 3: Painting buildings in the landscape

One of the most effective buildings in a landscape is a white building with a red roof. Rather than giving the building a coat of white paint, give it a blue shadow side to shape it.

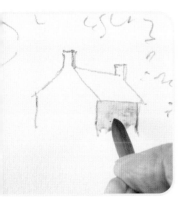

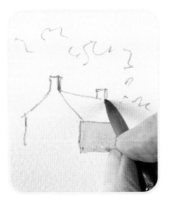

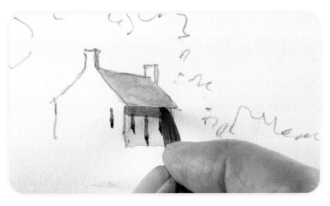

1 Decide which side of the building will be in shadow, and with a weak, watery blue wash, block in that side.

2 Run a shadow line down one side of the chimneys in the same weak wash.

3 When you're painting a building into a landscape you do not need to give lots of detail – just suggest the different parts of the building in distinct colours. The roof here is light red mixed with burnt sienna for a pantile shade; with a dark, but not black, mix of blue and burnt sienna run in for the suggestion of narrow windows. Run a shadow mix of blue, alizarin crimson and burnt sienna under the roof to 'sit' it on the building; this is effective even from a distance.

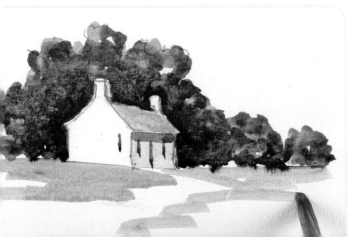

4 Your buildings will truly 'pop' out of the landscape if you suggest a bank of trees behind them. Tap on a base layer of yellow ochre directly behind the building, then go over the yellow with dabbed areas of green and burnt sienna mixed. Leave some yellow shining through. Dab in a strong blue (your sky colour) where the trees meet the buildings, to help the buildings stand forwards. Soften the blue in places with a clean, damp brush. Finally, ground the building in the landscape with a swathe of land beneath it.

THE PAINTING

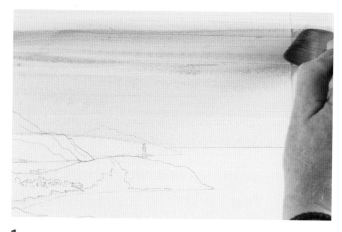

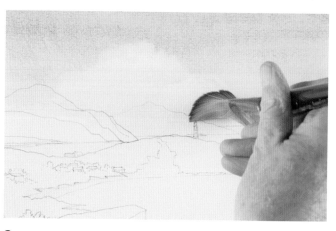

1 Prewet the sky with plenty of water and the larger flat wash brush. Wash in the sky using cobalt blue on its own. Keep the wash stronger at the top, weaker as you come further down.

2 Mop up any excess drips along the bottom of the sky. Then, with a clean, damp large flat wash brush, lift out a few large, fluffy clouds.

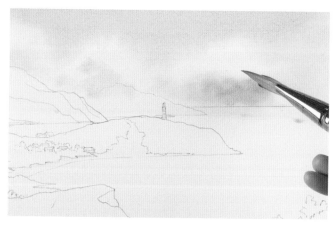

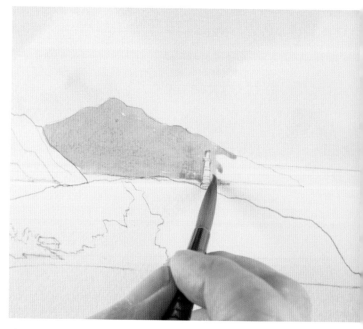

3 To put in shadows at the base of the clouds, mix cobalt blue with light red and alizarin crimson; this gives a slight purple tone to the blue. Once you've dropped in the colour, soften it upwards into the lighter areas of the clouds with a clean, damp brush, and mop up any excess. Allow to dry.

4 Start to work on the distant hills. Use the size 8 round brush to apply yellow ochre mixed with a touch of Hooker's green and lots of water. Fill in the hillside, working carefully around the lighthouse.

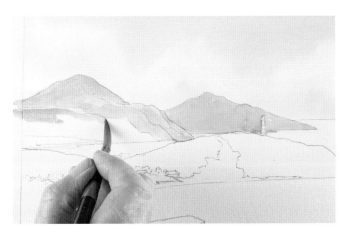

5 Block in the next adjacent hill in the same way.

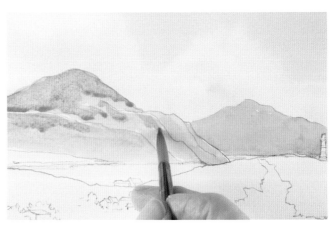

6 Drop in a few other colours while the paint is still damp. Begin with a touch of dilute light red – dab this in here and there, leaving areas of the green showing through underneath. This will help bring this hill further forwards in the scene than the one behind it.

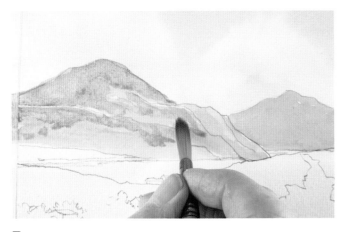

7 With a clean, damp brush soften the light red into the hillside. The shadows will give these hills more depth and shape at step 10.

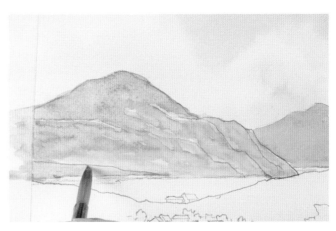

8 Run yellow ochre into the small strip of land in front of the hill – ensure that this yellow is not too strong.

9 Make up a shadow mix of cobalt blue (the blue of the sky), with alizarin crimson and a touch of burnt sienna to tone down the mix to a dark aubergine colour. With the tip of the round brush, put the colour on, keeping it fairly strong, and following the natural contours of the hill. Work carefully around the lighthouse.

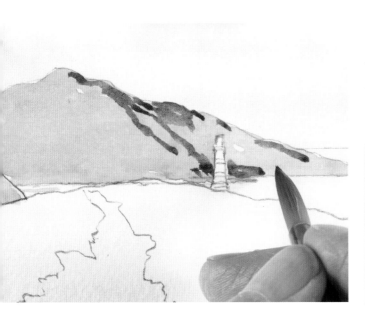

Charlie's top tip

This shadow mix is quite dark but because of the alizarin crimson it is also quite warm. This mix works for most scenes, except for snow scenes (as in the *Snow on the Moors* project on pages 72–83).

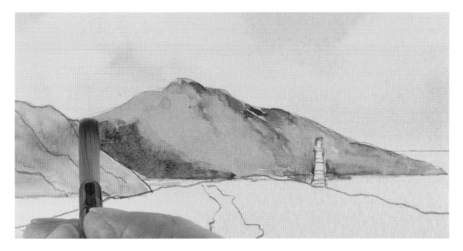

10 With a clean, damp brush, soften the marks here and there. Instantly, the hill will appear to have depth and shape. Imagine that the hill to the left casts a shadow on the distant hill: put this cast shadow in and, with the tip of the clean, wet brush, soften the shadow into the hill.

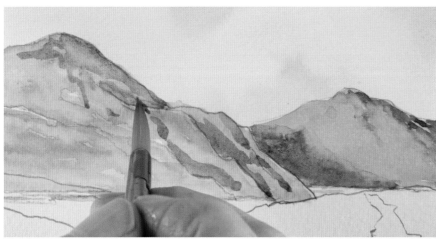

11 Apply shadow to the left-hand hill in the same way; add a few more ridges with the shadow mix to give additional shape and depth. Soften with a clean, damp brush.

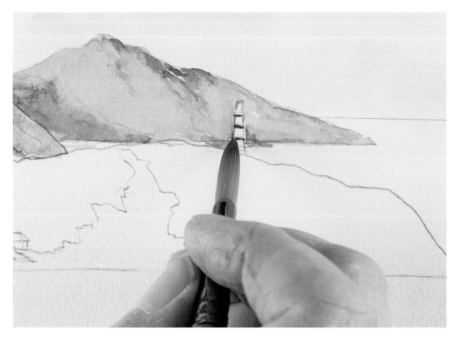

12 With alizarin crimson on the tip of the size 8 round brush, run in a few dark red/brown stripes around the lighthouse. Let them dry for a few seconds, then move on to work on the hill on the outcrop in front.

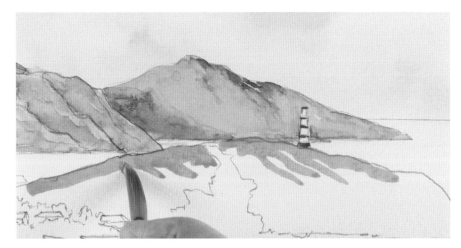

13 Go up and around the top of the hill with yellow ochre, and spread the colour down slightly.

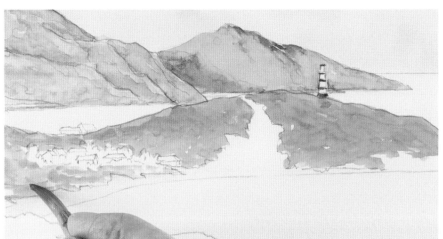

14 Mix Hooker's green with plenty of yellow ochre for a brighter, stronger green and go back over the hill, leaving areas of yellow ochre showing at the top. This way, you are catching the light: you will intensify this area later, once it's dry. The different strengths of green on this hill help it to stand forwards. Take the green mix all the way around the small village, then leave to dry for a few minutes.

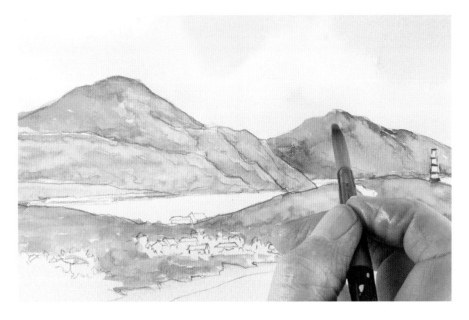

15 Add more light and intensity to the overall scene with cadmium yellow deep gouache. Run a little bit down the left-hand sides of the distant hills and soften it down into the other colours with a wet brush.

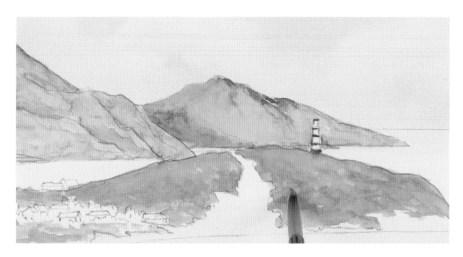

16 Strengthen the gouache and run it into the left-hand sides of the foreground hill. Put in a bit more at the top of the hill. Again, soften the colour down slightly with a clean, damp brush.

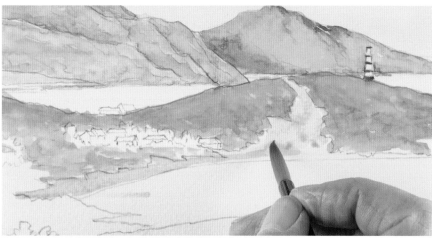

17 Mix yellow ochre and raw umber with plenty of water for the beachy area at the base of the outcrop. Run the mix up into the hilltop.

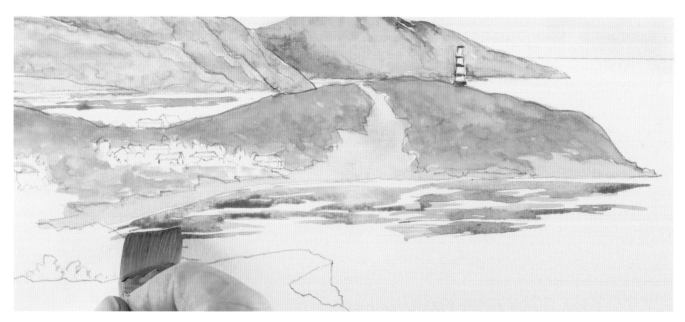

18 Switch to the small flat wash brush. Make up a stronger mix of Hooker's green and yellow ochre, and put in a few touches below the landline, for reflection. Do the same for the hills behind, and dot in raw umber for the reflections of the sandy areas. Let the reflections dry before going any further.

19 Mix cobalt blue (again, the sky blue) with a hint of Hooker's green for the sea; make sure the mix is quite dilute. Start at the horizon line with a good sharp edge, using the small flat wash brush. Work carefully around the hills and the lighthouse, and leave touches of white paper showing. Stop when you are level with the base of the outcrop.

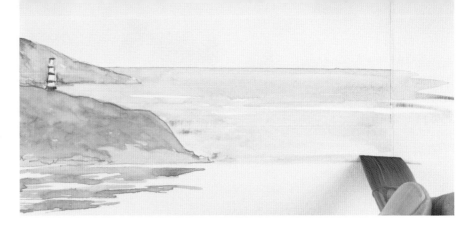

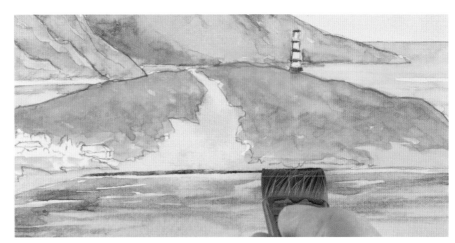

20 Paint quickly over the reflections you laid at step 18.

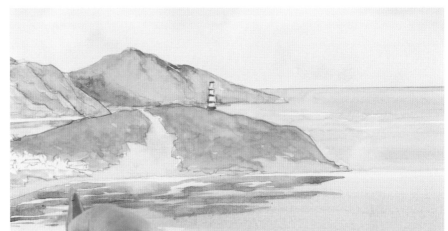

21 Using the shadow mix (cobalt blue, alizarin crimson and burnt sienna), put in a darker area where the land meets the sea.

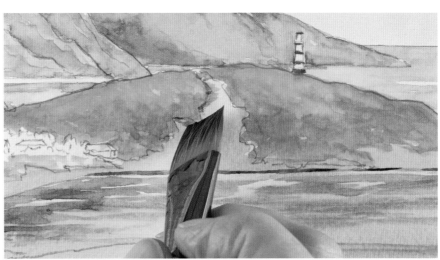

22 Run a little shadow into the hillside, along the edge of the sandy path upwards, bearing in mind all the time that your light comes from the left.

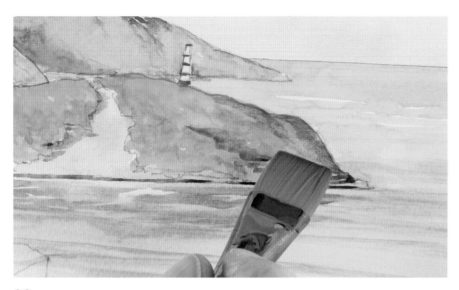

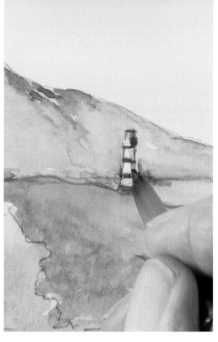

23 With a clean, damp brush, soften the shadow marks. This helps to make the foreground land really stand out.

24 Before you start on the buildings to the left of the lighthouse, put a shadow into the lighthouse itself: this is a very quick stroke through the white and the red stripes, which are now dry.

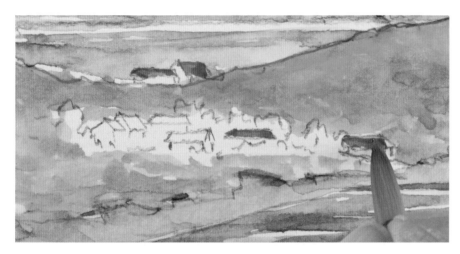

25 Block in the roofs of the buildings in light red, and leave the buildings themselves white.

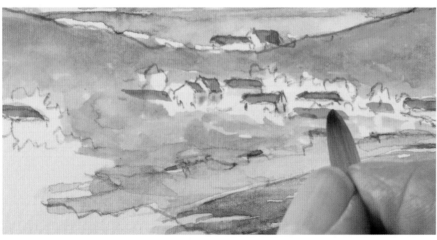

26 Stroke a tiny amount of cobalt blue into the dark sides of a few of the buildings, to highlight the white sides that are catching the light.

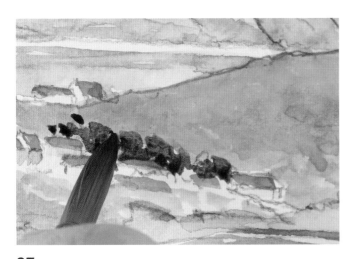

27 Dot in a line of trees directly behind the cluster of buildings in a mix of Hooker's green and burnt sienna. Work these in carefully around the buildings, with the size 8 round brush, to help the buildings take their place in the landscape.

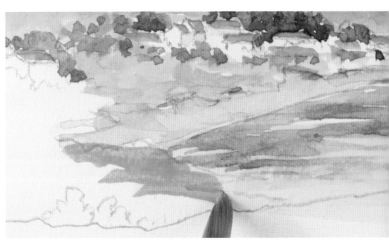

28 Run in a small amount of yellow ochre for a hint of beach on the left of the painting.

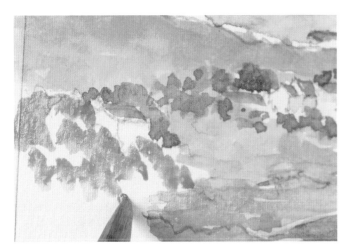

29 For some larger trees on the left side of the scene, stipple in the suggestion of the foliage with yellow ochre.

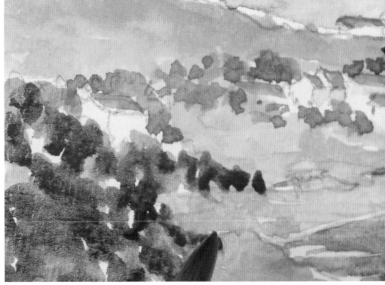

30 Go over the yellow with a strong mix of Hooker's green and light red.

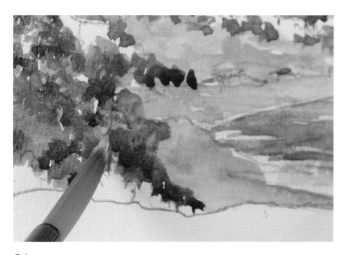

31 Highlight the foliage with a little cadmium yellow hue gouache.

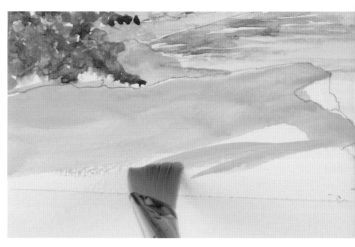

32 Take up cadmium yellow deep gouache on the smaller flat wash brush. Keeping the area bright, work into the foreground.

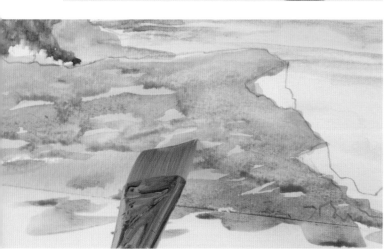

Charlie's top tip: gouache

The beauty of gouache is that, because it's opaque, it will cover the colours underneath – such as the overlapping area of sea – for a more seamless shoreline.

33 Mix Hooker's green with the yellow ochre and go in over the pure yellow wet-into-wet. This will help the colours soften and run into each other.

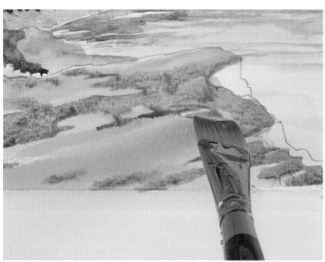

34 With a clean, damp brush, soften the areas slightly to help them blend. The bright yellow underpainting helps the foreground really stand out in the landscape.

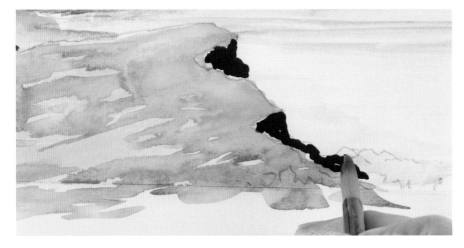

35 Block in the cliff faces in a nice, dark Payne's grey gouache – this area of darkness will contrast with the areas of light on the top of the cliff. Soften the gouache with a touch of water.

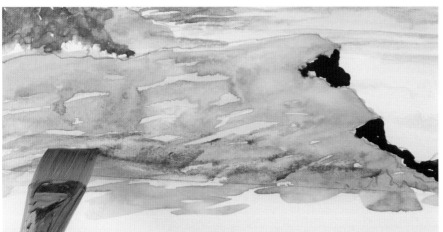

36 Go back into the grassy clifftop with cobalt blue and the small flat wash brush, to add some more depth and texture.

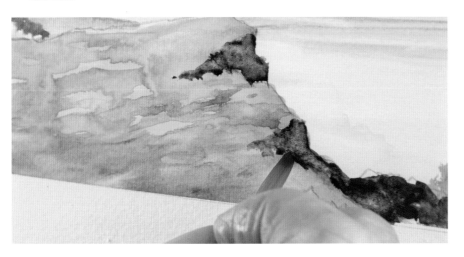

37 Once the cliff faces are dry, go back into them with a clean, wet brush to take out some of the darkness and density.

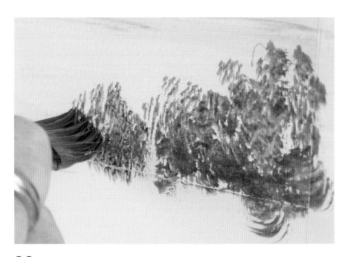

38 Split the bristles of the flat brush. Work into the area on the right of the scene in a mix of Hooker's green and burnt sienna, stippling on the colour.

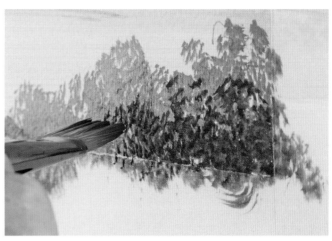

39 Put a little bit of cobalt blue into the base of this foliage area, again stippling the colour on with the split flat wash brush.

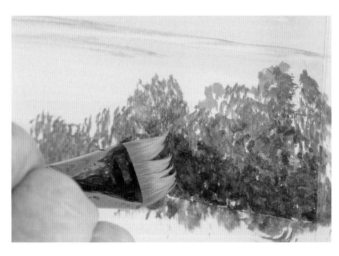

40 Finally, highlight the foliage with cadmium yellow deep gouache, repeating the stippling motion.

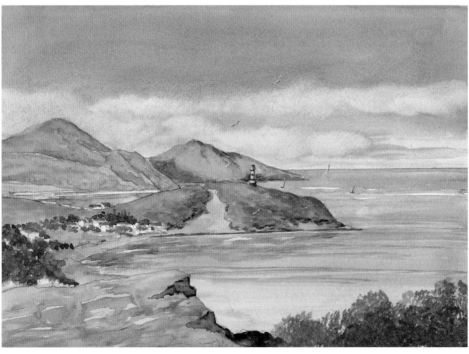

You'll notice a difference between the finished painting opposite, compared with the painting on the left.

I used my size 8 round brush with a little white gouache to stroke in a few little sails in the distance. I also highlighted the areas of white on the lighthouse.

With a touch of cobalt blue into Hooker's green, I strengthened the greens on the hill on which the lighthouse stands. Finally, using my rigger brush, I added a few ticks of white gouache into the sky to suggest seagulls.

If you choose to trace several copies of the outlines at the back of the book, you can work, and rework, your paintings and make a new variation to the outcome each time.

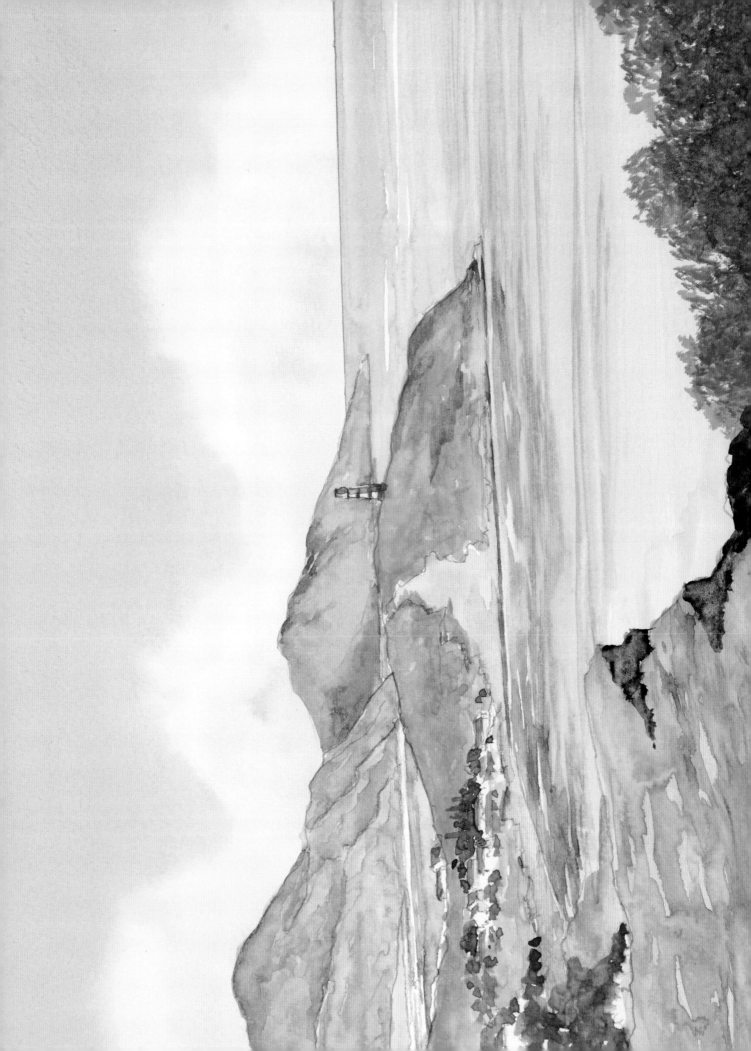

3. WARM CLIMES

There are plenty of greens in this landscape, from subdued to bright. This range of different tones and shades of green also gives a feeling of recession and strength. It is this recession that will create the depth and atmosphere of any painting.

This is a warm location, so make sure your water mix is neither too dark nor cold: use cobalt blue – the blue of the sky – with a tiny touch of light red.

BEFORE YOU START

YOU WILL NEED
30mm (1½in) flat wash brush, 19mm (¾in) flat wash brush, size 8 round brush, size 4 rigger, plastic card, outline 3 (see page 100)

COLOURS NEEDED
Yellow ochre, light red, cobalt blue, alizarin crimson, Hooker's green, raw umber, burnt sienna

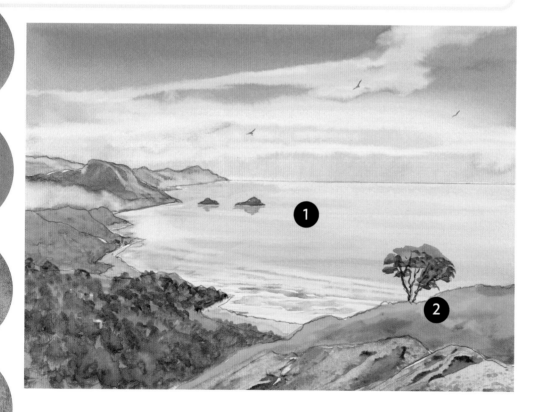

Technique 1: Painting calm water

One thing to remember when painting calm water is to keep your brushstrokes horizontal. This will help the water look flat.

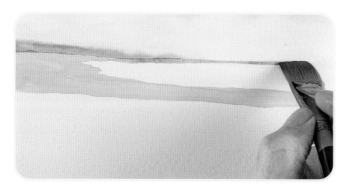

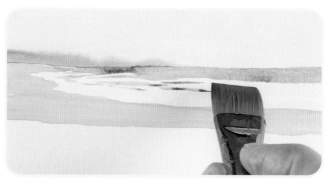

1 The colour of the water should be based on the colour of your sky. If you've used cobalt blue in your sky wash, repeat the colour in the water and mix in a little Hooker's green and burnt sienna to darken it slightly. Keep the colour fairly dilute and run in a horizon line first, on a flat wash brush.

2 Bring the colour forwards, making it milder as you move into the middle-distance. Wiggle the brush over the paper to let some of the white paper show through and suggest small, ripples of wave in places.

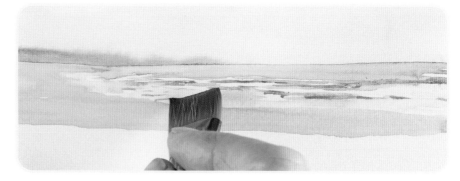

3 Work underneath some of the white areas with a darkened version of your water mix, to suggest shadow. Then, with a clean, damp brush you can sweep over the whole water area to soften the colour into the paper.

Technique 2: Painting a tree using a rigger brush

Rigger brushes are often underused because artists coming afresh to these brushes are afraid of them and unsure of how they should be used. Originally manufactured to paint in rigging on tall ships, riggers are also useful for painting trees.

Avoid holding the brush at the very end or too close to the ferrule; hold the brush midway up the handle and let the brush flick and bounce around naturally to give you delicate twigs on a winter tree, for example.

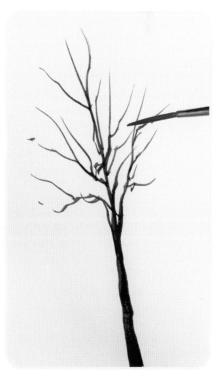

Paint in a tree from the base upwards; press the brush hard against the paper at the base of the trunk so that the paint spreads for a broader stroke. As you work upwards, lift off the brush slightly for a thinner stroke.

Let the very tip of the rigger bounce around to create twigs.

THE PAINTING

1 Prewet the sky with the 30mm (1½in) flat wash brush. Mix yellow ochre with a touch of light red, and run this along the bottom of the sky.

2 Bring the colour upwards slightly, then mop up any excess colour along the bottom.

3 Run dilute cobalt blue from the top of the paper coming down to meet the yellow–light red area of the sky.

4 As the colours meet, use the sharp edge of the brush to form a few clouds. Let all the colours run and merge but control your water and mop up any drips.

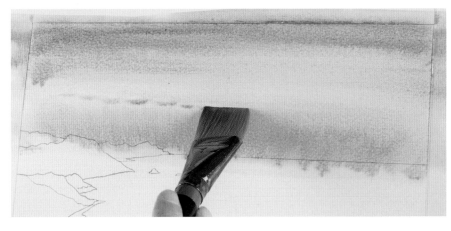

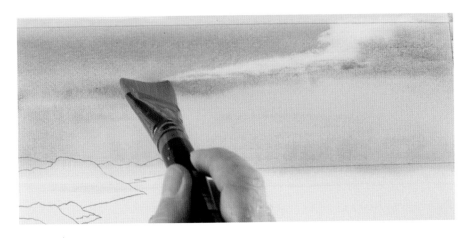

5 As you lift out some larger clouds with a clean damp brush, try to leave a little dark area at the bottom of the cloud for shadow.

Charlie's top tip: landscape painting — the order of work

With most paintings, once the sky has dried, I build up the painting starting in the distance, with objects getting stronger as I move forwards, so that in the foreground I have good, strong colours. To me the composition of a painting is like any good book: with a beginning, middle and end.

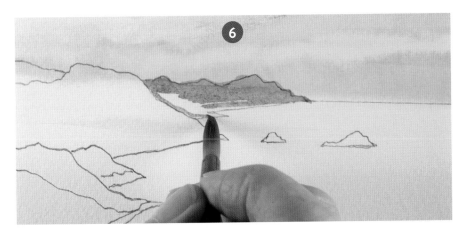

6 On the size 8 round brush, load a mix of cobalt blue, alizarin crimson and light red. Fill in the far-distant hills. Note that there is no detail on these hills as they are a long way off.

7 Once you have blocked in the hills with the paint, wash out your brush, squeeze out any excess moisture and suck out a little light to give more shape to the hills.

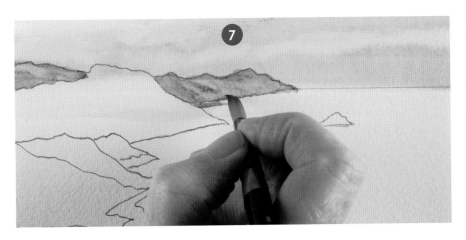

Charlie's top tip: distance and details

Avoid including too much detail in the distance of your coastal landscapes. The more detail you put in, the further forwards you will bring the object, which may throw the perspective of your painting out of balance.

8 Coming further forwards across the hills to the next large outcrop, use the same colour mix but with a little more cobalt blue in the blend to make it stronger.

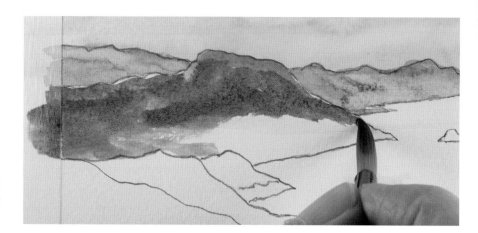

9 Wash out the brush, squeeze out any excess moisture and take out a little more light to add shape to the outcrop.

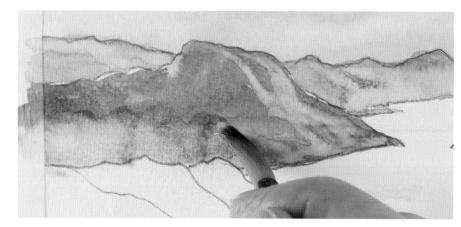

10 For the next mix, start to place your greens. Make up a mix of Hooker's green with plenty of yellow ochre and block in the next group of hills on the left.

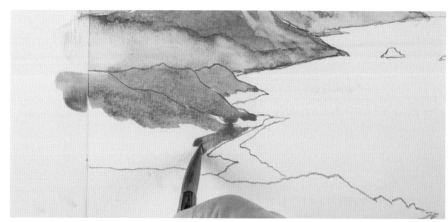

11 While the mix is still wet, warm it up here and there slightly with a few tiny touches of well-watered light red. Move the colour around with a clean, damp brush: this changes the look of the green and gives it texture. Allow to dry.

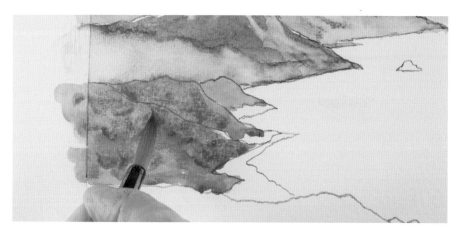

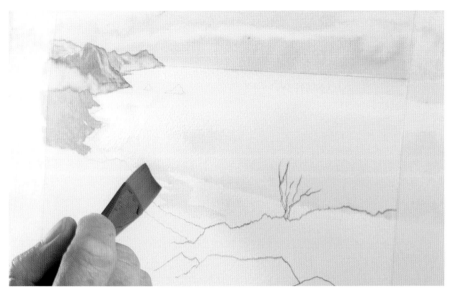

12 Prewet the sea area with the smaller flat wash brush, coming up to the shoreline but leaving a little white paper here and there.

13 Lay in a wash of dilute cobalt blue – the blue of your sky. As you move further forwards, gradually add a little more colour. Work carefully around the shoreline.

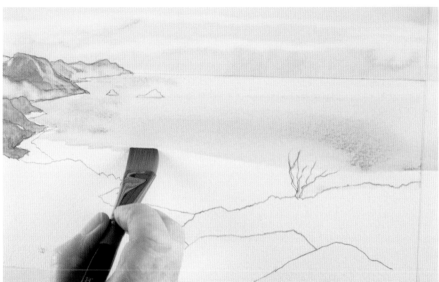

Charlie's top tip: singing the blues

Use the same blue for the sea as for the sky. Likewise, make sure that any shadow mixes contain the same blue that you have used in the sky.

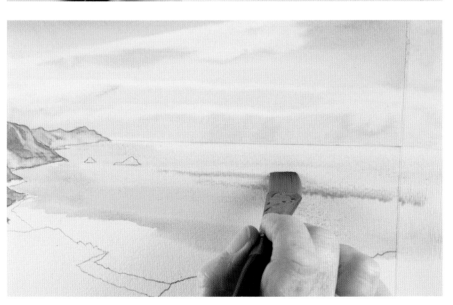

14 At this stage, add a tiny hint of very pale, dilute light red into the water. While the colour runs, stroke through the colours with a clean, damp brush to merge them together. This will result in a soft, natural effect.

15 Blend the colour with the sharp edge of the bristles, leaving a few tiny touches of white paper showing through. Soften the colour well with the clean, damp brush so there are no harsh lines.

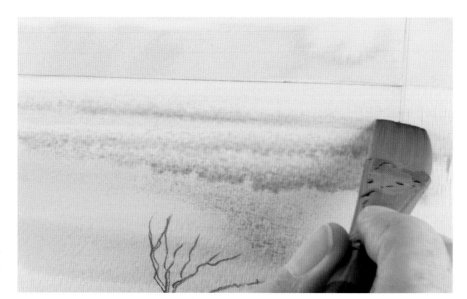

16 Take up the dilute cobalt blue again. As you come towards the shoreline, wiggle the brush to depict waves, ensuring you leave plenty of white paper showing for the surf.

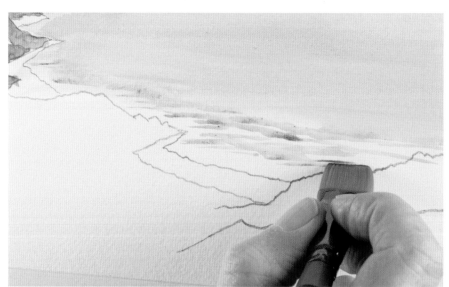

17 While the sea area is still slightly damp, drop in a little touch of dilute yellow ochre for beachy coves along the shoreline. Allow to dry.

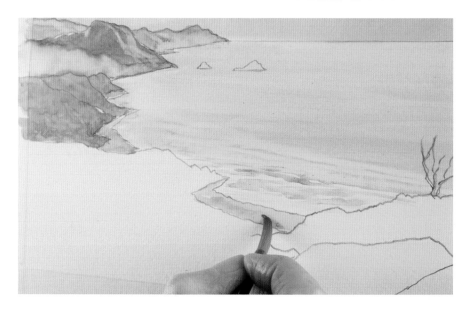

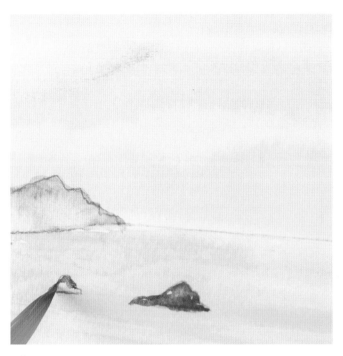

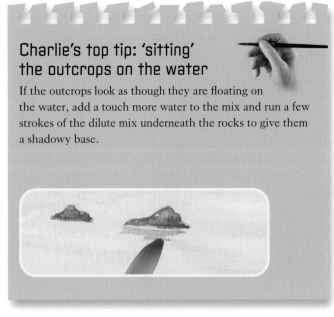

Charlie's top tip: 'sitting' the outcrops on the water

If the outcrops look as though they are floating on the water, add a touch more water to the mix and run a few strokes of the dilute mix underneath the rocks to give them a shadowy base.

18 Before you start work on the foreground, drop in the little outcrops in the sea in the middle distance. These should be in a fairly dark mix of cobalt blue with a touch of light red.

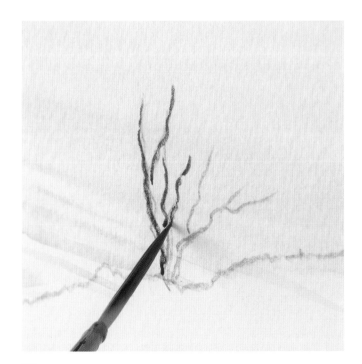

19 Mix raw umber with a touch of cobalt blue – with the rigger brush, run in the twigs and boughs of the foreground tree. This is not a particularly large, dominant tree so there is no need to fiddle with it too much. Its purpose in the landscape is to break up the fairly solid profile of the foreground.

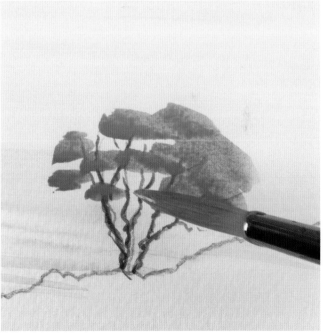

20 Make up a fairly strong Hooker's green and yellow ochre mix. With the size 8 round brush, dab the green on from the top of the tree, and with the bristles held horizontally against the paper, drag the colour downwards.

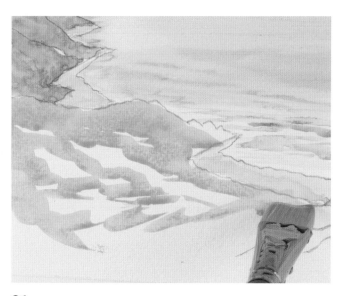

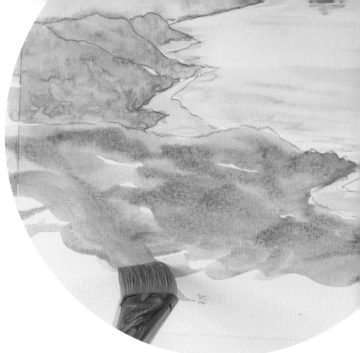

21 Take up the smaller flat brush. Beginning with yellow ochre, work into the foreground area. Don't block in the area; wiggle the brush around, leaving plenty of white paper showing through.

22 With a mix of Hooker's green and yellow, heavier on the yellow, go back over the foreground area. Again, remember to make your brushstrokes count – let your brushstrokes shape the land.

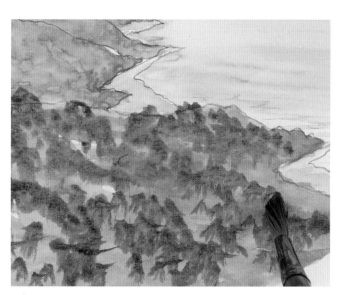

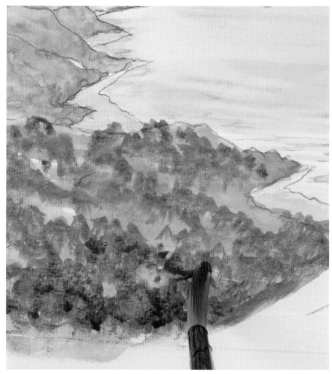

23 With the round brush and a mix of Hooker's green and burnt sienna, begin to dab in the suggestions of trees over the foreground area. Apply the green in a variety of depths, to hint at the uneven texture of the land beneath.

24 Put in a touch of cobalt blue around the bases of the trees. It may seem odd to put blue into your trees or foliage, but as it is on top of the other colour mixes it will not come out excessively blue.

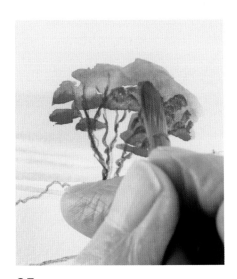

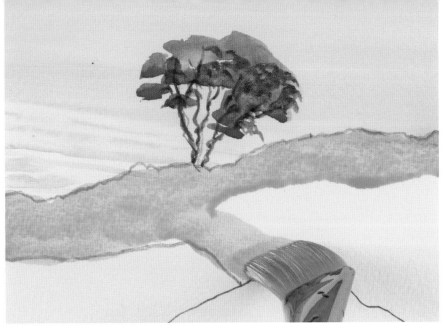

25 Once the foreground tree has dried, dot a little bit of cobalt blue onto the right-hand side to give the foliage more depth. Give it a minute to dry.

26 The hillside in the foreground is more of a bracken colour, with a few shrubs dotted in here and there. Wash in strong yellow ochre on the smaller flat wash brush, using your brushstrokes to define the shape of the land.

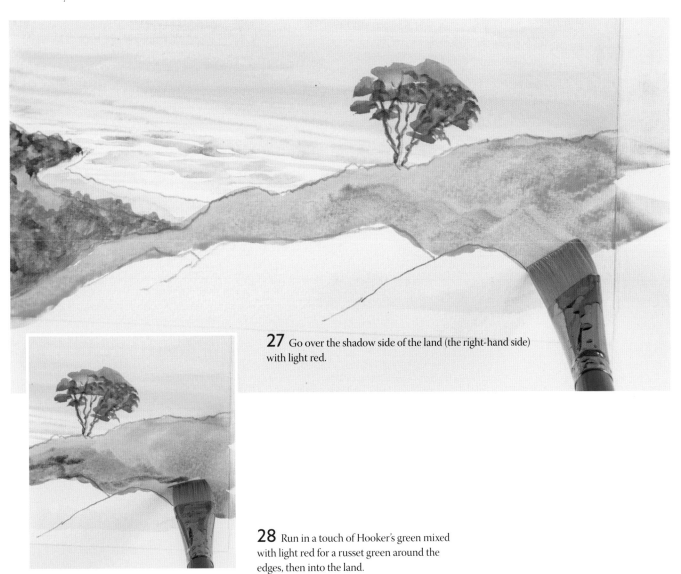

27 Go over the shadow side of the land (the right-hand side) with light red.

28 Run in a touch of Hooker's green mixed with light red for a russet green around the edges, then into the land.

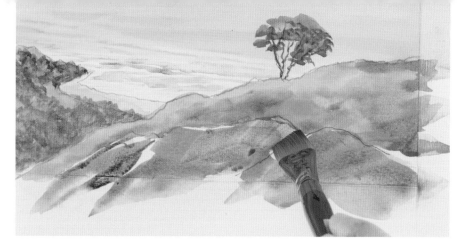

29 With a little yellow ochre and raw umber, drop in the very foreground – don't think about it too much, 'bash' the colour on! Go back over with cobalt blue mixed with burnt sienna to fill in any pale areas and add texture.

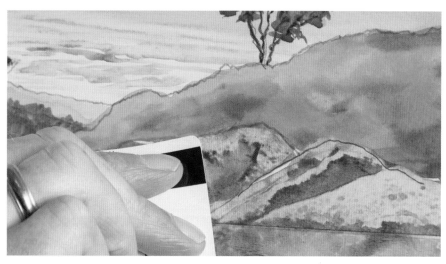

30 Scrape over the still-damp foreground in places with the corner of a plastic card. This reveals the paper surface and gives texture to a cluster of rocks. Draw the card diagonally down to shape the rocks.

31 Finally, suggest the forms of a few gulls in the sky to give additional life to your painting. These can be simple tick-marks in a cobalt blue–light red mix, put in using the rigger.

Charlie's top tip: good odds
Avoid putting in an even number of birds in the sky at step 31 – it will throw off your composition!

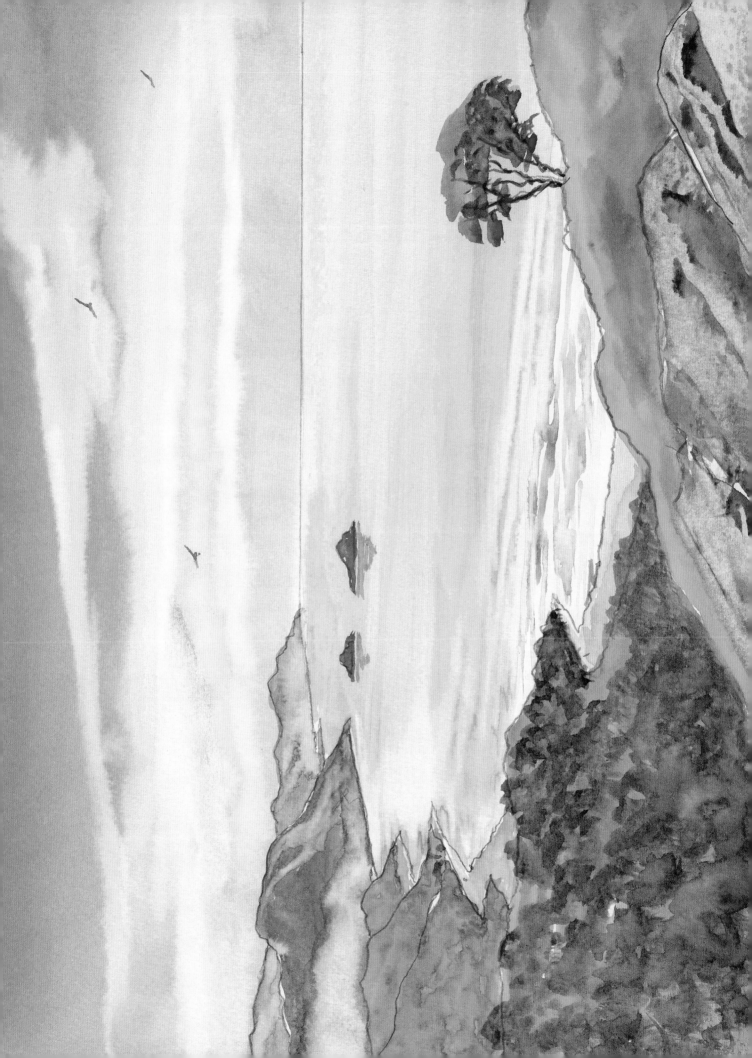

4. INLET

This landscape focuses on a little river flowing out to the sea. With rich autumnal colours, you can create a particularly atmospheric painting, but be careful not to make it too 'moody'!

BEFORE YOU START

YOU WILL NEED
30mm (1½in) flat wash brush, 19mm (¾in) flat wash brush, size 8 round brush, size 4 rigger, outline 4 (see page 101)

COLOURS NEEDED
Yellow ochre, burnt sienna, ultramarine blue, Hooker's green, Charles Evans Sand, light red, raw umber

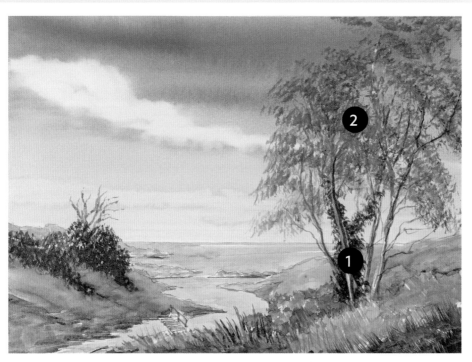

Technique 1: Taking out light

Many artists new to watercolour believe that once you've made a mark on the paper you can't then reintroduce light. This is not true – it is actually very simple to take out the light.

I have laid some very strong, heavy staining colours in this vignette; but if I want to include a telegraph post in the scene, with a light side to it, it is still possible.

1 When the scene is almost dry, I can use the edge of the bristles of my 19mm (¾in) flat wash brush to lift out the post.

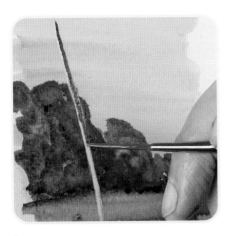

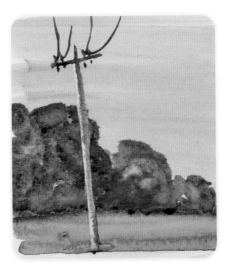

2 I establish the light side of the post, and run colour – on a size 4 rigger – down the dark side of the post, leaving the light side unpainted.

Any additional details can be dotted into the vignette, wet-into-dry.

Technique 2: Stippling foliage

You do not need to dot in every individual leaf using the fine point of a small brush. Splay the bristles of a medium brush such as the size 8 round brush, and stipple in the foliage to suggest individual leaves.

Splay the bristles of your brush using your fingers (right), and dab the brush head into the paint in the palette (far right).

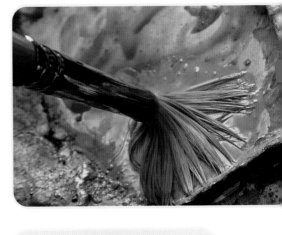

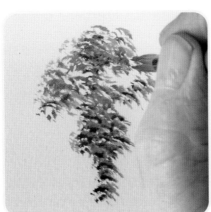

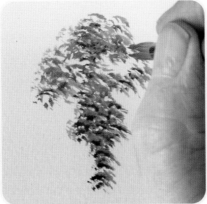

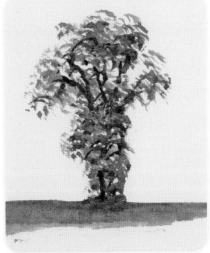

1 With the bristles loaded with colour – here, yellow ochre – tickle the brush head over the paper in a downwards motion for the first layer of foliage.

2 Go over the yellow foliage with a mix of Hooker's green and burnt sienna, still keeping the bristles split and stippling in the same direction.

3 Finally stipple in areas of blue for shadows within the foliage, working in the same way as for the previous layers of colour.

THE PAINTING

1 Prewet the paper with lots of water on the large flat brush, again giving yourself time to get all the colours on.

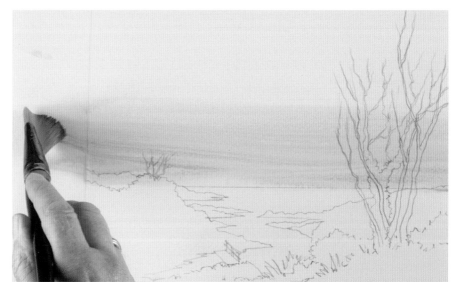

2 Start with yellow ochre in the bottom third of the sky. Mop up any excess.

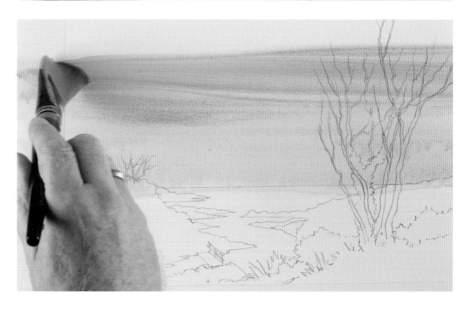

3 Put in a little burnt sienna above the yellow ochre and again mop up any drips. It is important to keep control of the water in watercolour painting.

4 With a mix of ultramarine blue and burnt sienna, heavier on the blue, come down from the top of the paper and through the other colours. Leave a little yellow ochre showing through, then again mop up any excess.

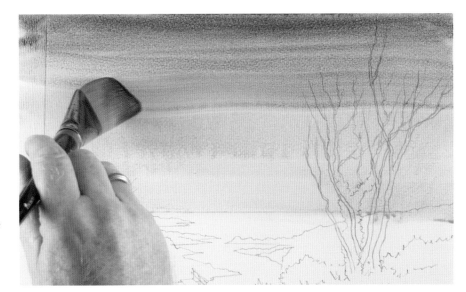

5 Strengthen the mix, and with a wiggling motion, put in the shadows of a few clouds.

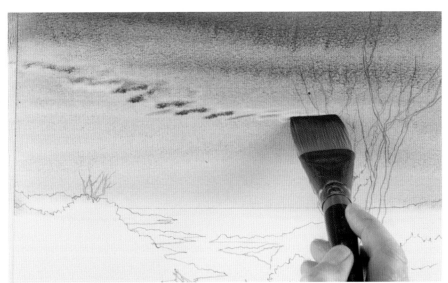

6 Wash out your brush and squeeze out any excess moisture. With the side of the brush, suck out lighter cloud forms, retaining the dark shadows underneath.

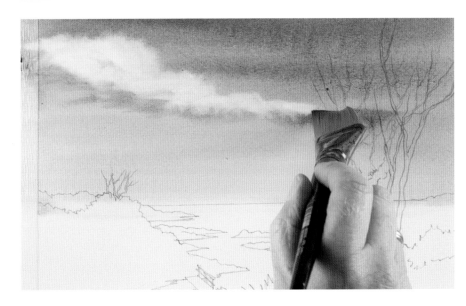

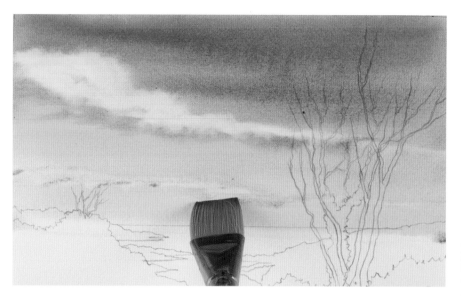

7 With the paint that you have picked up on your brush, drop some colour into the base of the sky for more, distant, cloud. Mop up any excess once again, then let the sky dry.

Charlie's top tip: painting through solid objects

Work straight through the trees at step 8 – don't work around them. If you spend time painting around objects, you will risk the paint drying and leaving you with hard edges. You will be able to lift out the tree branches later.

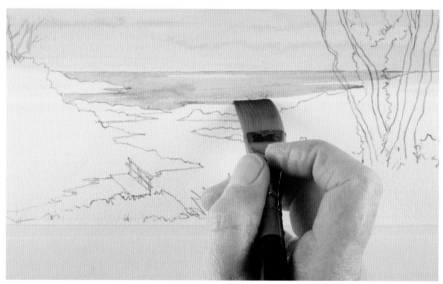

8 Mix ultramarine blue with a touch of Hooker's green and burnt sienna. On the smaller flat wash brush, paint in the sea, working forwards from the horizon line and leaving touches of white paper showing through.

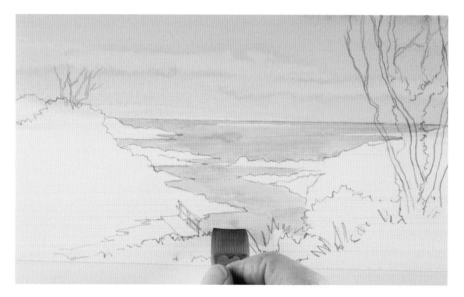

9 Make the colour of the sea lighter as you move forwards, to keep the strongest blue on the horizon line.

10 With the sharp edge of the squeezed-out flat brush, suck paint out to reveal the light in the tree.

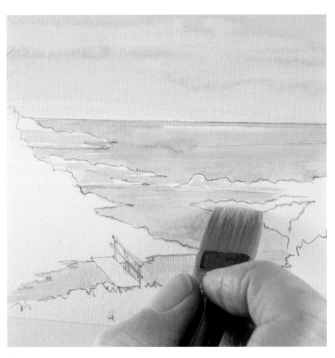

11 With the smaller flat brush and a touch of Sand, fill in the outcrops of land starting in the distance and working forwards.

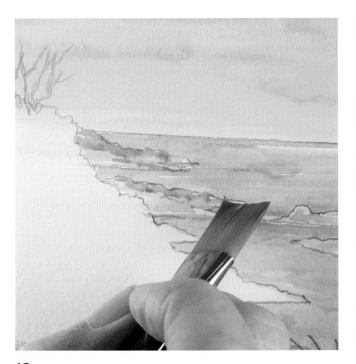

12 Put in a mixture of Hooker's green and yellow ochre on the tops of the outcrops. Use the corner of the brush to drop in green on its own.

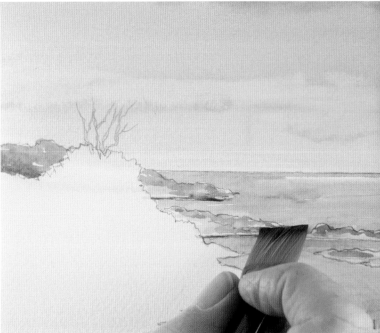

13 Strengthen the mix for the area of land on the far left of the scene. Then use ultramarine on its own at the base of the outcrops to anchor them in the water.

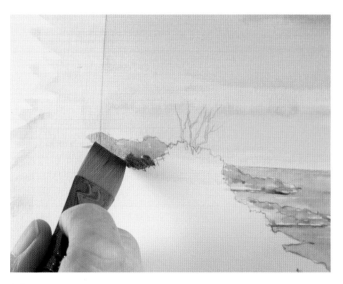

14 Put a little bit of blue into the base of the distant green land. This will help it drop behind the foreground and suggest its distance.

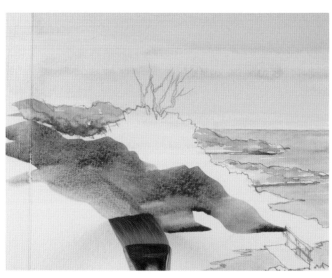

15 Mix Hooker's green and light red – aim for an autumnal tone and move away from bright greens. Flow the colour into the foreground land on the left, and add slightly more water to the brush as you reach the base of the land. Notice that the top of the area is left blank – the bushes at the top will be shown as standing further forwards in the scene.

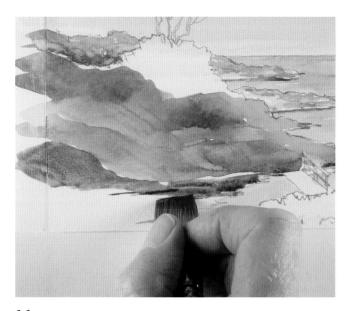

16 Fill in the bank at the base with raw umber mixed with a touch of ultramarine blue.

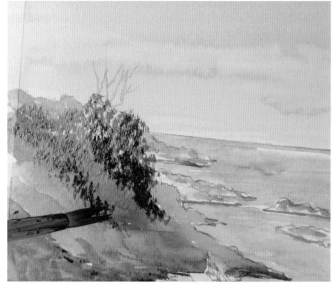

17 Split the bristles of the size 8 round brush – the Aquafine brushes can withstand a lot of abuse! Stipple on the bushes on the top of the land in a mix of Hooker's green and burnt sienna. Splay the foliage area down into the land beneath.

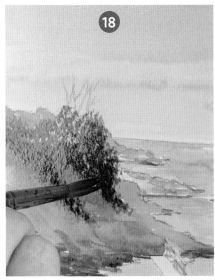

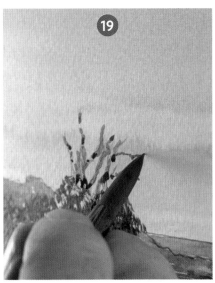

18 Stipple in a touch of ultramarine blue into the right-hand side of the foliage.

19 Dampen the bristles and take up more of the same mix from step 16 – notice how the brush tip resumes its original shape regardless of how it is treated! Run in some twigs and branches on the tree at the top of the mound of land.

20 Move across to the land on the right. Paint through the trees in yellow ochre on the smaller flat wash brush.

21 While the wash is still wet, go in with more yellow ochre mixed with Hooker's green. Dab on the colour, leaving some of the yellow showing through here and there.

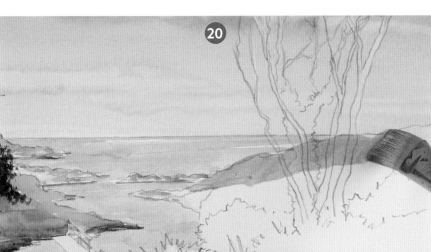

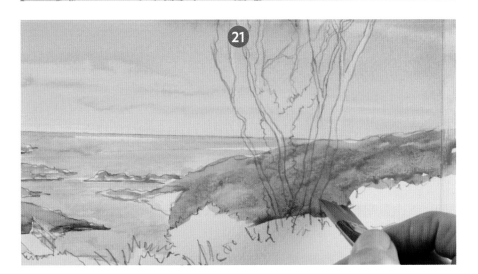

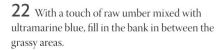

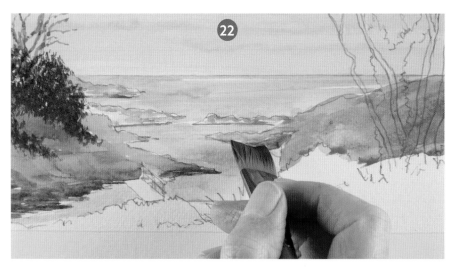

22 With a touch of raw umber mixed with ultramarine blue, fill in the bank in between the grassy areas.

23 With a clean, damp brush, lift out the light on the foreground trees while the banks are drying.

24 To put in the little bridge in the middle distance, use raw umber on the tip of the size 8 round brush. Carefully run in the handrails first.

25 Run in the slats, leaving a little bit of the paper visible here and there – the bridge is a very simple little structure.

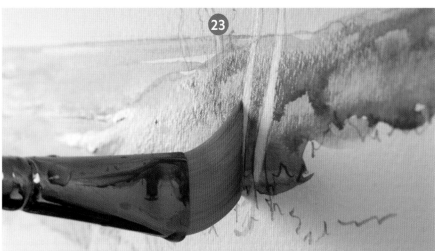

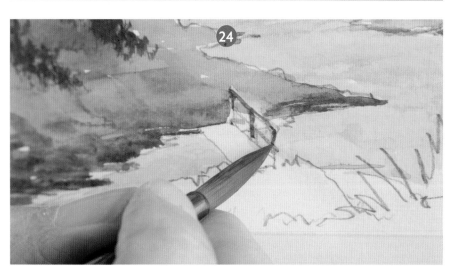

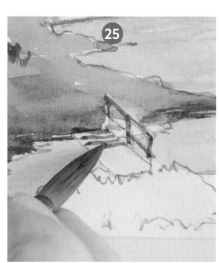

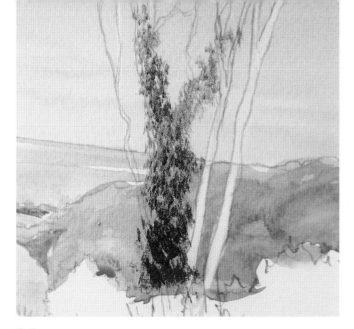

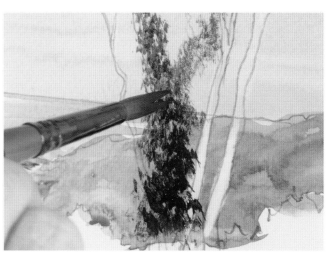

26 Move on to the trees. Make up a strong mix of Hooker's green and burnt sienna. Split the bristles of the round brush and stipple on an ivy-clad trunk. Work from the bottom of the tree upwards, in the direction of growth.

27 To give the trunk of the tree a little more depth, mix ultramarine with burnt sienna. Split the brush once more and stipple the darker mix onto the right-hand side of the trunk.

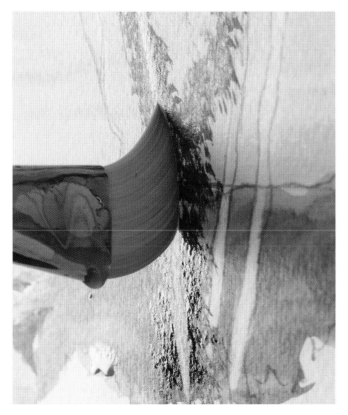

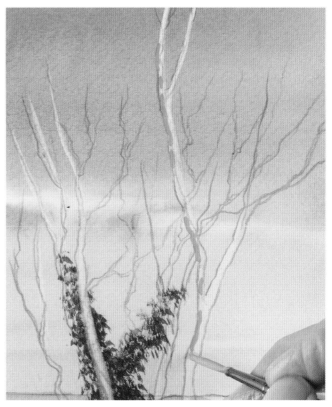

28 Where you've painted through the foremost trunk with the ivy you can now lift it out with a clean, damp flat wash brush. Allow the area to dry.

29 Use the rigger brush to put in some strong light onto the left-hand side of the twigs, in yellow ochre.

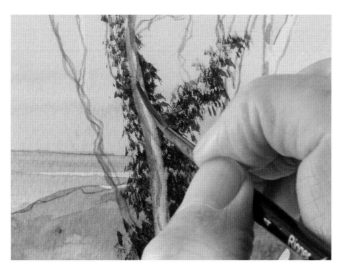

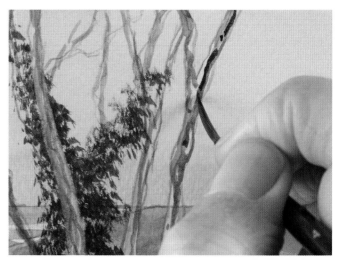

30 Run a mix of raw umber with a touch of ultramarine down the right-hand sides of the same twigs, to darken them. Leave a few areas of lifted-out light here and there. Keep in mind that you don't need to paint in too many twigs, as the foliage from steps 33 to 35 will cover many of them.

31 The last colour on these branches and twigs is a black mix of ultramarine blue and burnt sienna. Run the strong black mix down the right-hand side of the foreground tree to bring it forwards in the scene. Put in a few twigs coming out from the trunk, using the rigger.

32 Split the small flat brush in the well of yellow ochre in your palette.

33 Remember to keep the foliage autumnal. Begin by stippling on a layer of yellow ochre. Stipple in a downwards direction, and repeat the brushstroke when applying burnt sienna.

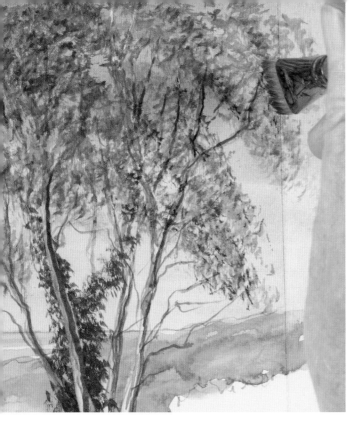

34 Mix Hooker's green with burnt sienna – don't overdo the green – and stipple in over the top of the yellow and burnt sienna.

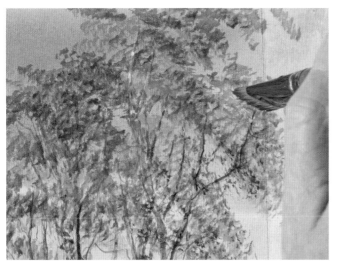

35 Finish with a touch of ultramarine blue, stippled on, to the darker, right-hand sides of the foliage-covered branches.

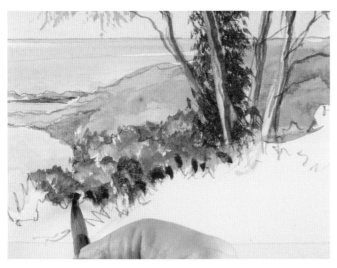

36 Stipple in some bush detail at the base of the tree in Hooker's green and burnt sienna with the size 8 round brush. Go back in with a little blue at the base to darken the area.

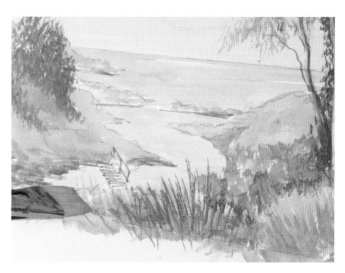

37 Take up the small flat brush to put in the foreground grasses. Starting with yellow ochre, flick the colour upwards as well as daubing it on in places. Swiftly follow with Hooker's green and yellow ochre in a stronger mix than you used on the hillside, and again flick the colour upwards in an exaggerated motion – bending the bristles – to form tall, individual blades of grass.

38 To put in some taller, sharper grasses, use the same mix as in step 37 but apply the colour with the sharp edge of the brush. Place good, strong grasses in the foreground that give the impression that we can look through them to the foliage behind.

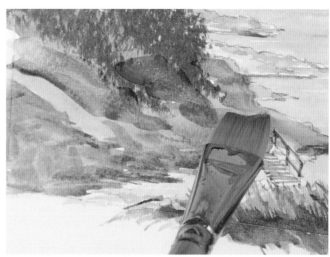

39 Darken the foreground grasses with ultramarine mixed with a touch of burnt sienna.

40 Finally, warm up the left-hand hillside – glaze over the top of the area with dilute light red to lighten it.

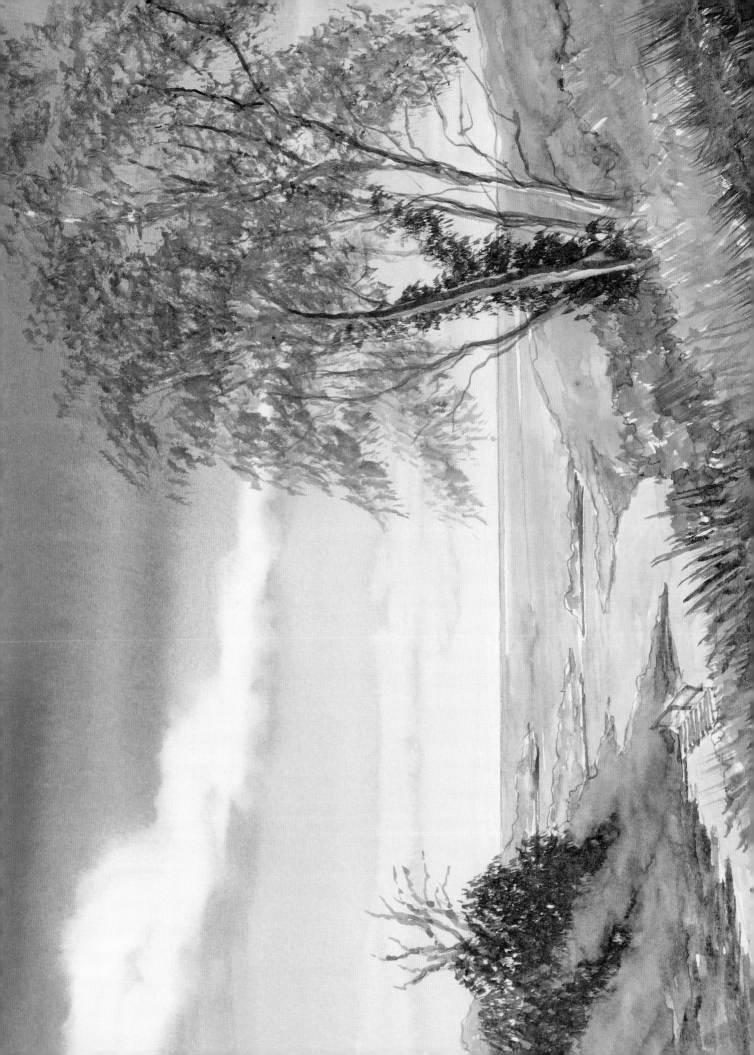

5. SNOW ON THE MOORS

I love painting a snow scene: however, you must be careful not to include too much white in the scene. This seems like a strange thing to say, but there are many colours in snow that are reflected from the environment, such as the sky and the shadows. Don't be afraid of making the snow dark with warm hues.

BEFORE YOU START

YOU WILL NEED
30mm (1½in) flat wash brush, 19mm (¾in) flat wash brush, size 8 round brush, outline 5 (see page 102)

COLOURS NEEDED
Ultramarine blue, Hooker's green, yellow ochre, raw umber, light red, burnt sienna

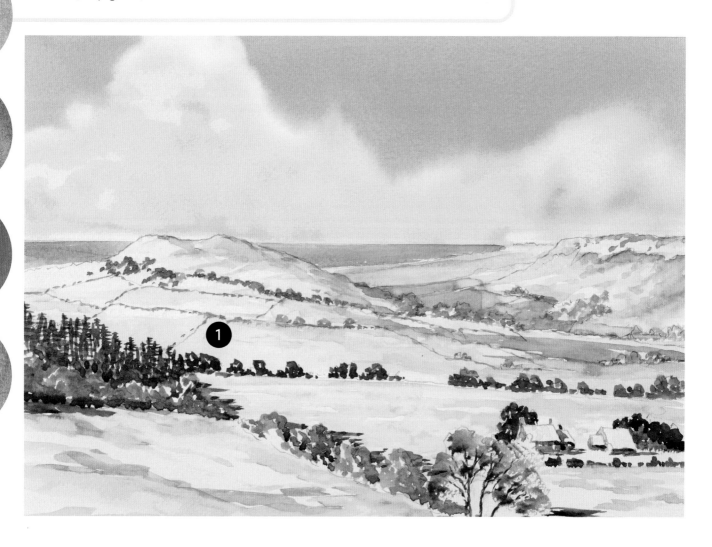

Technique 1: Suggesting distant trees

Distant trees and hedges do not need to be painted in slavish detail – simply give the impression of the tree and hedge shapes for an impactful effect.

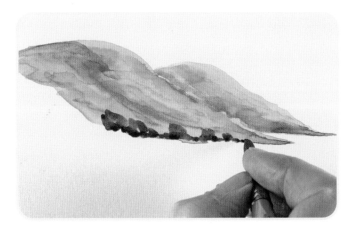

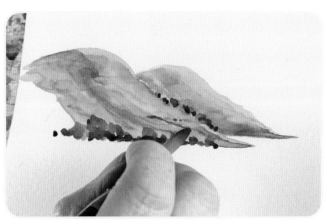

1 Here, I have used a mix of Hooker's green and burnt sienna to dab on a few trees at the base of these hills, using the size 8 round brush. Don't paint in individual trees; just 'blobs' to represent them.

2 As you work further up the hill, put in a few dabs of colour up the side of the hill, and some fine lines working across the hill, for hedgerows.

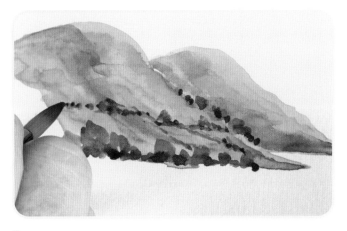

3 Make smaller dabs and dots along the tops of the hedgerows and the trees to give them a little extra shape.

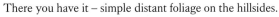

There you have it – simple distant foliage on the hillsides.

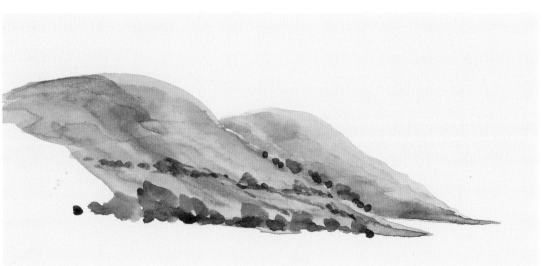

THE PAINTING

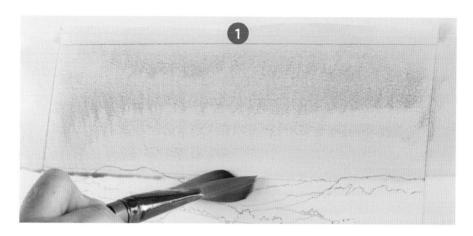

1 With the large flat brush, prewet the sky. This is going to be another very simple sky as there is plenty going on on the ground. Put in a graduated wash in dilute ultramarine blue for the sky, and mop up any excess along the base. Keep the sky stronger at the top.

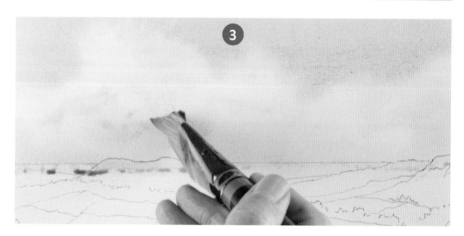

2 Suck out a few large clouds.

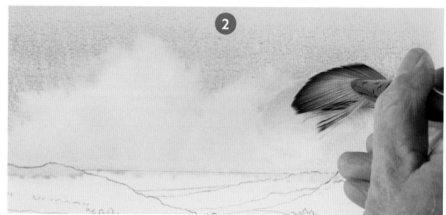

3 To put in a little cloud shadow, lift out the cloud itself then drop a bit of colour back in at the base. Again, mop up any excess moisture, and leave your simple sky to dry.

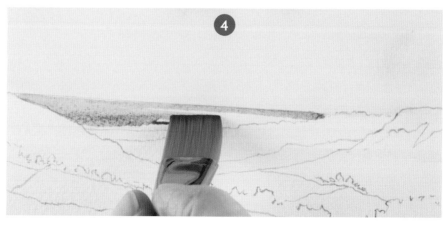

4 Into the ultramarine, add a tiny touch of Hooker's green and run in a small amount of sea visible in the distance, this time on the smaller flat wash brush. Allow to dry.

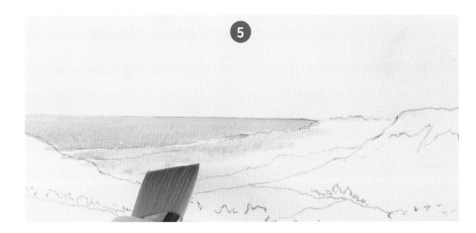

5 In the far distance, run in a little stretch of beach in weak yellow ochre.

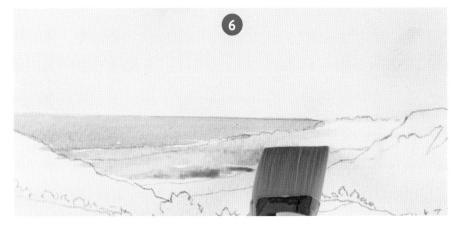

6 Run weak raw umber directly beneath the area of yellow, and let the raw umber bleed into the yellow ochre.

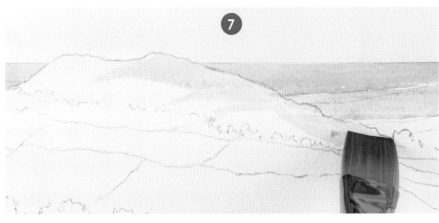

7 Most of the rest of the scene is now snow-covered. Do remember, though, that snow is not all white; there are many colours in snow. Dab a tiny touch of light red into the ultramarine blue from the sky. Mix in plenty of water and run in the farmost hillside. Keep the colour darker on the right-hand side and spread it towards the left where the mix should be weaker.

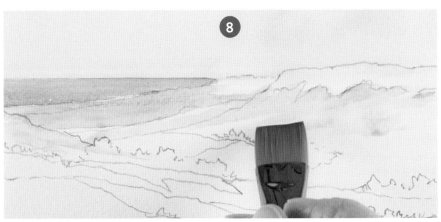

8 Do the same on the body of the hill on the right. Leave a few areas of white paper showing through here and there.

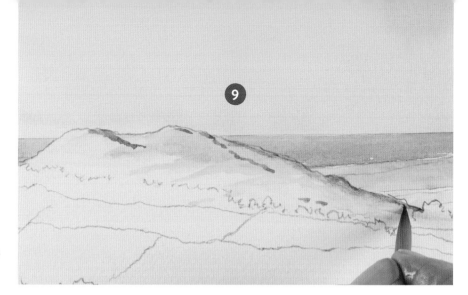

9 Change to the size 8 round brush. In the ultramarine blue–light red mix (heavier on the light red this time), put in a few touches on the first hill (from step 7), down the right-hand side to darken it. As you put these strokes in, follow up with a clean, damp brush to soften the strokes at the edges.

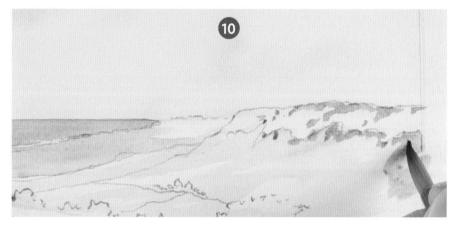

10 Put in the darker mix over the top of the hill from step 8, and gradually stroke it downwards. Think about the shapes of your hills; your brushstrokes will show so make them count and use them to indicate the shapes of the hills.

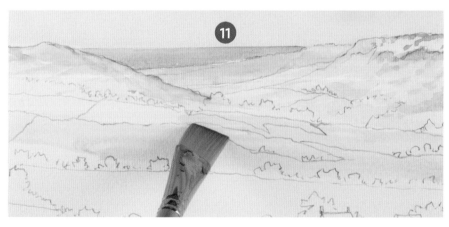

11 In a very weak, dilute mix of ultramarine blue and burnt sienna, fill in the middle-distance section between the hills. Let this dry slightly before going in to add detail.

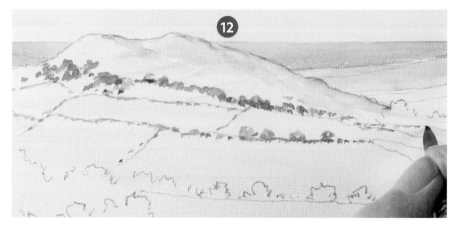

12 In a stronger mix of ultramarine blue and burnt sienna on the same round brush, give the impression of hedgerows and treelines; dab on a few trees going up the hillside in the form of lumps and bumps. With the tip of your brush pull down a few strokes around the hills for field lines: these help to give the hills shape. Leave a few areas of underpaper showing through.

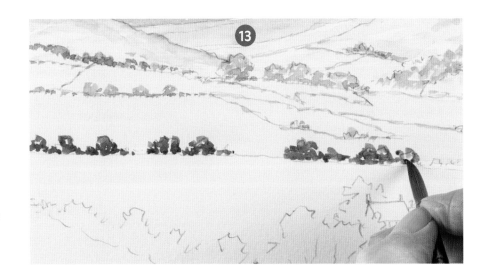

13 Strengthen the mix slightly and put in the row of trees in the middle distance.

14 Start to add in a few other colours into the same area, including dabs of dilute light red and dilute yellow ochre, in a few simple strokes.

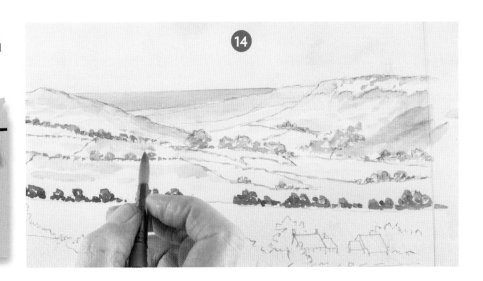

Charlie's top tip: softening strokes

Don't leave these marks looking too sharp: soften them in slightly using a clean, damp brush to add different tones to the area.

15 Mix Hooker's green, burnt sienna and ultramarine blue: lay in a few pine trees as vertical lines, using the tip of the round brush. Bring down the colour behind the foreground trees. Put in a few horizontal lines through the vertical lines to give you a fir tree effect.

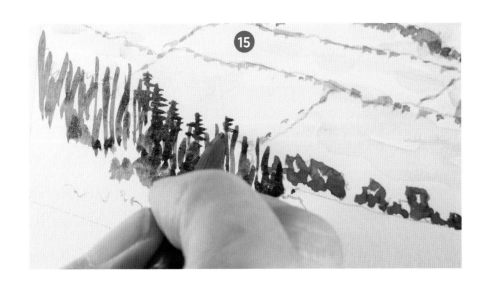

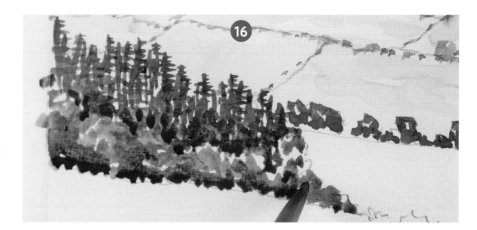

16 Dot a little bit of burnt sienna into the base of the trees to create bushes in front of them. Leave a little white paper showing through, and dot some strong blue at the base of the foliage and the tree line for shadow.

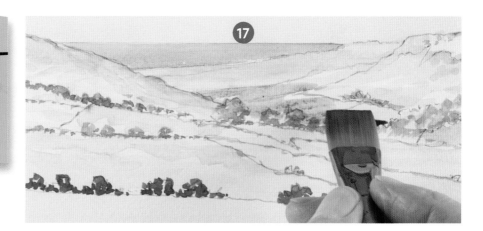

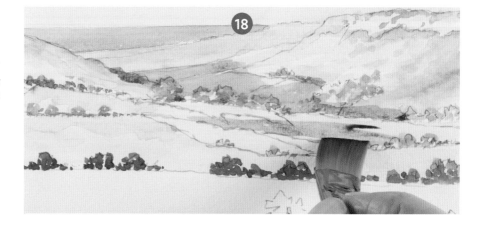

17 The light in this scene is coming from the left, hence the areas of white left on that side of the scene. The largest of the hills casts a shadow on the land to the right. Make up a shadow mix from ultramarine blue and light red and plenty of water. Be bold and brave, and put in a nice, dark shadow.

18 At this stage you can also put in shadows cast by clouds over the land.

78

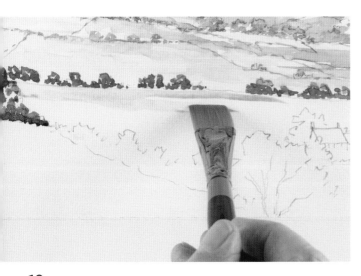

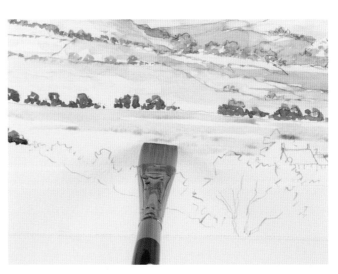

19 Move in to the foreground. Run yellow ochre across the land and soften it in with a clean, damp brush.

20 Go back to the ultramarine blue–burnt sienna mix (mix in more blue) and run this across the midground land, coming from the right. Let the fields and the hills dry before you move on to the buildings.

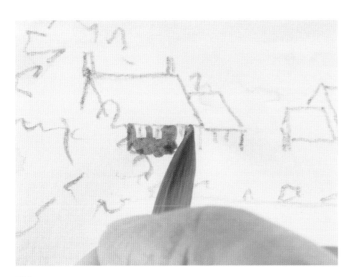

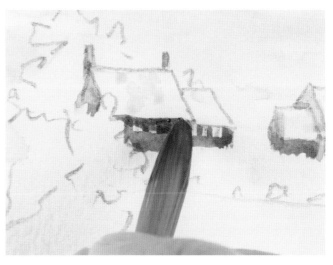

21 With a mix of raw umber and burnt sienna on the size 8 round, fill in the fronts of the buildings. Put more water into your brush of paint for a weaker mix, to be applied on the lighter sides. For buildings in the distance you do not need to go into too much detail.

22 Put dilute ultramarine into the roofs here and there. Run a mix of fairly strong ultramarine blue and burnt sienna under the roofs where they meet the fronts of the buildings, for shadow.

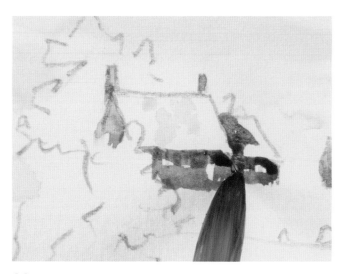

23 Put in the cast shadows at the same time – the bigger buildings on the left will cast shadows on the smaller buildings on the right.

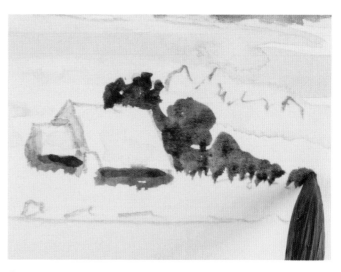

24 The buildings will be pushed forwards by the trees that stand behind them. Mix Hooker's green, ultramarine and burnt sienna to a dark, rich tree-green. Tap this colour on carefully around the buildings.

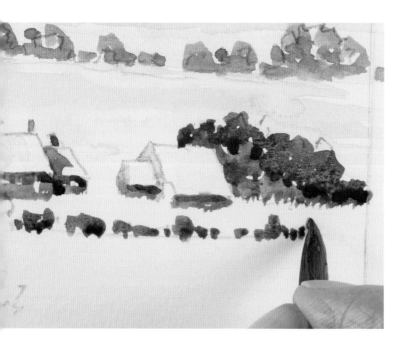

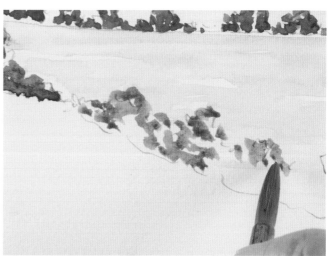

26 With a touch of raw umber on the size 8 round brush, dot in the hedges in the foreground. Leave areas of white paper showing as you dab on the colour.

25 Fill in the rest of the tree area behind the buildings in a touch of ultramarine and burnt sienna. Dot in a low hedgerow in front of the right-hand building in the same mix.

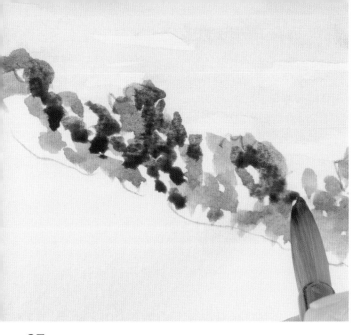

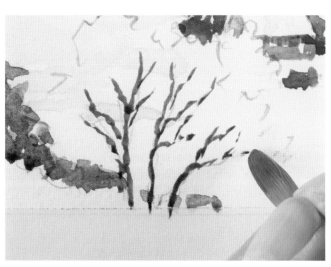

27 Again, dab on a little bit of strengthened ultramarine blue–burnt sienna mix in the right-hand side of some of the trees along the hedge line.

28 With a mix of raw umber and ultramarine blue, paint in the trunk and branches of the large foreground tree. Drag down with the tip of the brush to create the boughs and twigs.

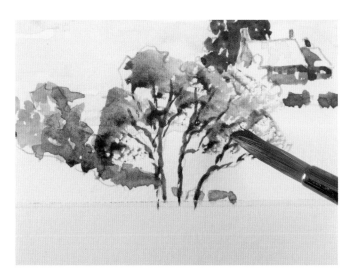

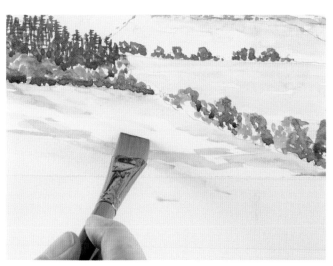

29 As this is a wintry scene, there is not much thick foliage on the tree. Drag down the impressions of thinner twigs over the crown of the tree, with the side of the same brush in the same grey–brown mix. Leave to dry.

30 With ultramarine blue mixed with a touch of strong light red and the small flat wash brush, put some strong contours into the foreground, then soften them down with a clean damp brush to create the impression of banks of snow. Leave areas of the paper white in places.

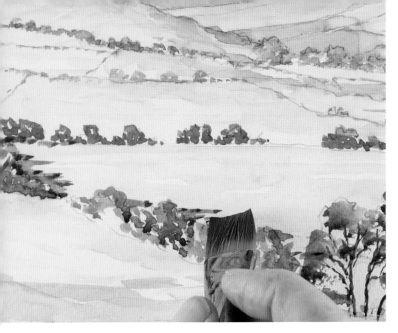

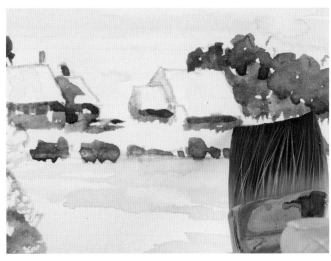

31 Begin to put in a few additional areas of shadow in the ultramarine blue–burnt sienna mix. Make sure the mix is not too warm. This shadow mix goes to the right of the fir trees and the large foreground tree. Put in a few touches on the right-hand side of the foreground hedgerow.

32 Run a little shadow under each of the buildings.

Charlie's top tip: shadow mixes

Usually my shadow mix would include alizarin crimson, but this would make the mix too warm for a snow scene.

33 Look over your painting as a whole. If you feel that the beach in the distance is too bright in colour, tone it down with a mix of ultramarine blue and burnt sienna, using the larger flat brush. This completes the painting.

6. STORM IN THE COVE

Lulworth Cove is an iconic coastal landscape in Dorset, England: it conjures up thoughts of smugglers and olden times. I have put in a fairly strong sky on this scene to create a dramatic atmosphere.

BEFORE YOU START

YOU WILL NEED
30mm (1½in) flat wash brush, 19mm (¾in) flat wash brush, size 8 round brush, outline 6 (see page 103)

COLOURS NEEDED
Yellow ochre, ultramarine blue, burnt sienna, Hooker's green, raw umber, alizarin crimson, light red, Charles Evans Sand, cobalt blue, cadmium yellow hue gouache

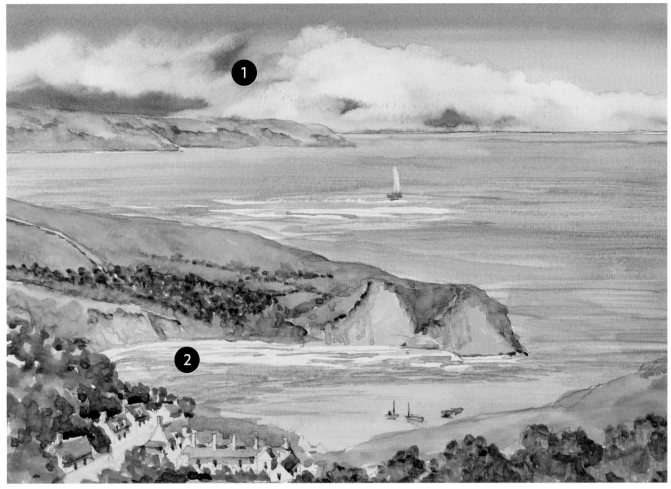

Technique 1: Painting a stormy sky

The shadows beneath the clouds are what give a stormy coastal scene its tempestuous mood. Use a large flat wash brush for the greatest impact here.

The sky in the project itself is quite mild but you can always trace the outline again and paint a variation of the scene with a truly stormy sky.

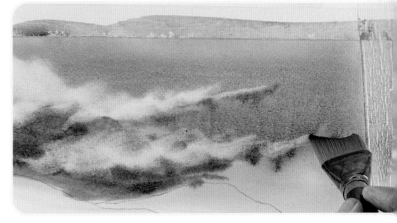

1 The sky itself can be laid in a dramatic wash of yellow ochre at the base, and burnt sienna above, with a mix of ultramarine blue and burnt sienna at the top of the sky. Darken, or strengthen, this mix with more burnt sienna and less water and swirl in some storm clouds over the top of the sky.

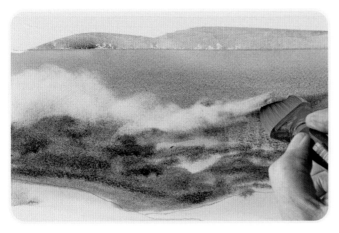

2 Wash out the brush and squeeze out the moisture with your fingers (see page 23). Using the side of the brush, take out some of the light from the tops of the clouds, in a swirling motion.

3 Let the sky dry fully before you continue with the scene.

Technique 2: Painting a stormy sea

In a similar way to the sky, you can give far more energy and mood to the sea in this project by following these steps.

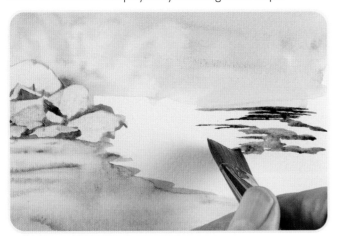

1 For a cold, dark sea shade, mix the blue of your sky with Hooker's green and burnt sienna. Fill up the sea area as far as the horizon line but not in a block of colour – imitate the movement of waves with your brush, leaving areas of white here and there. Weaken the wash as you move into the foreground.

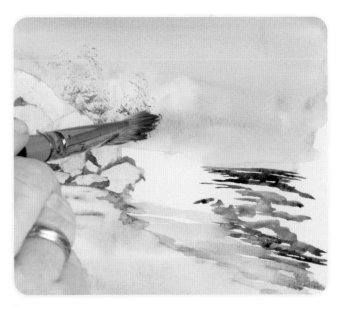

2 Strengthen the mix again with more blue; split a 19mm (¾in) flat wash brush in the sea mix in your palette, and stipple the sea colour into the sky for dramatic spray.

THE PAINTING

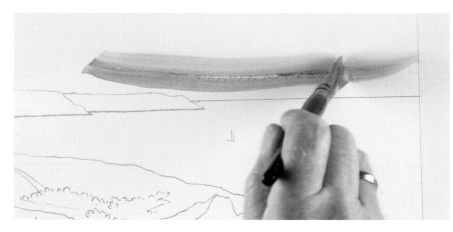

1 Use the small flat wash brush to prewet the sky – there is very little visible in this scene. Put in yellow ochre at the base of the sky and mop up any excess along the horizon.

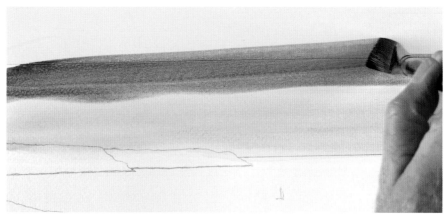

2 Mix ultramarine blue and burnt sienna for a strong, overcast sky. Bring this in from the top of the painting but don't stop working in the colour when the blue meets the yellow, otherwise you will end up with hard lines.

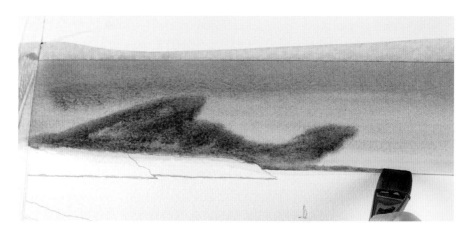

3 Strengthen the ultramarine blue–burnt sienna mix. Bring this down to the base of the sky and across the top line of the sea.

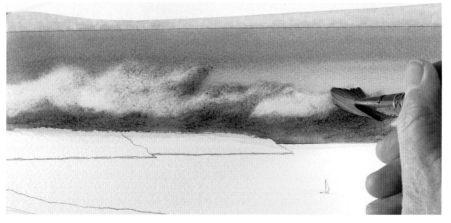

4 With a clean, damp brush, suck out some light on the tops of the clouds. This gives the impression of a storm coming in over the sea. Allow to dry.

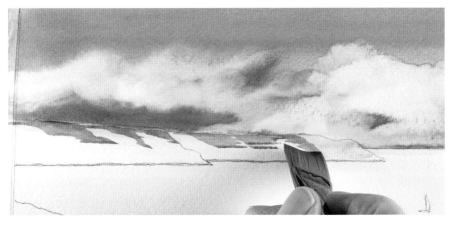

5 Mix a small amount of Hooker's green and yellow ochre. Where the sky is the darkest, put in the lightest area of land to counterbalance the darkness. Drag the colour from the top of the land downwards.

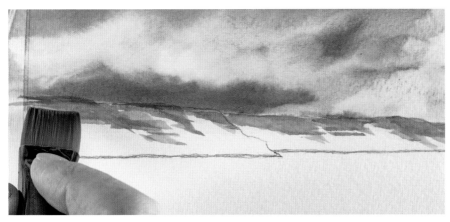

6 On top of this mix, run a little bit of cadmium yellow hue gouache.

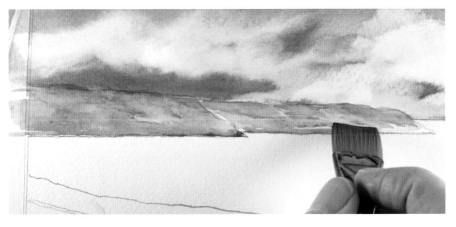

7 Beneath the grassy clifftops, put in dilute raw umber and bring this colour downwards with a nice, sharp brush edge as far as the waterline and along the base of the cliffs themselves.

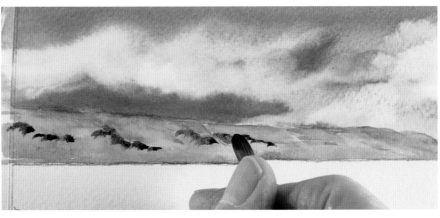

8 Take up the size 8 round brush and a shadow mix of ultramarine blue, alizarin crimson and burnt sienna. Where the grassy clifftops meet the cliff face, run a bit of shadow. Run some of the mix between the two cliffs as well, to separate them. Soften down the marks you make using a clean, damp brush. All of this attention will help make the grass 'sit down' on the clifftop.

9 Next, move on to the sea. Switch back to the small flat wash brush for this. Because of the stormy nature of the sea, this sea needs to be much colder in tone. Mix ultramarine blue with a touch of Hooker's green and burnt sienna, and dilute it well. Start the sea in the distance with a nice, hard line along the horizon.

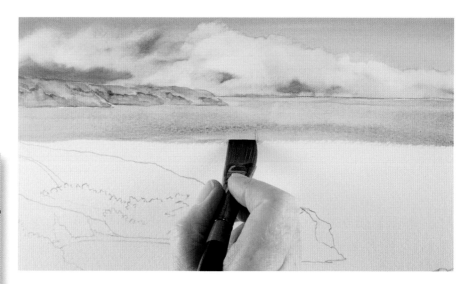

Charlie's top tip: order of work

If I paint the headland before the sea, I have to paint the sea very carefully around it; however, if I paint the sea first, I can work the headland in over the top.

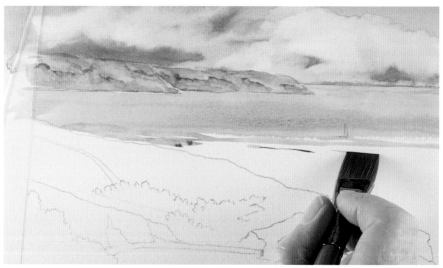

10 Bring the colour down towards the foreground. Note that there is a small boat in the midground of the scene. You do not need to work carefully around it – work through it, and take out the white of the boat at step 13. Do, however, leave some areas of paper unpainted around the boat to show the waves around it.

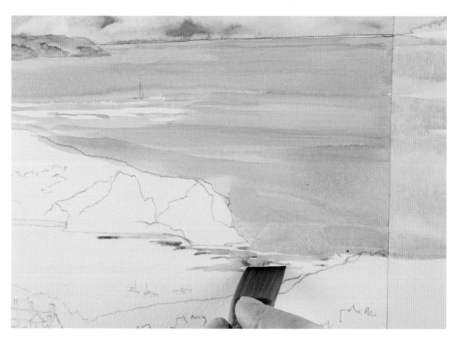

11 Leave a few areas of white in the foreground but not too many or the sea will look too busy. As you reach the base of the headland, start to leave more white to indicate movement in the sea. As the sea approaches the beach, leave areas of white to represent surf.

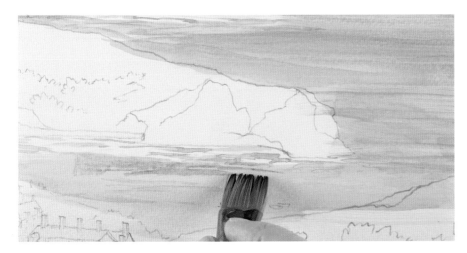

12 Smooth through the rippled water, making the whole area sit flat. Darken the sea directly under the headland.

13 With the tip of the size 8 round brush, take out the sail of the midground boat.

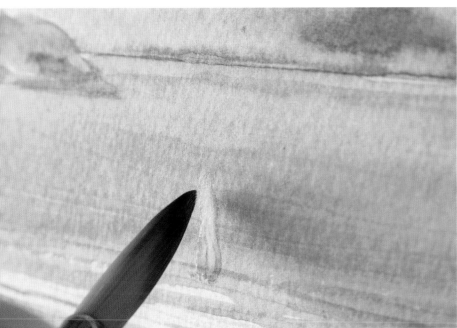

Charlie's top tip: leaving and lifting out light

Many artists use masking fluid to leave areas of the painting white, but this risks taking off the surface of the paper with the masking fluid, or leaving too sharp a white line that can't be removed afterwards.

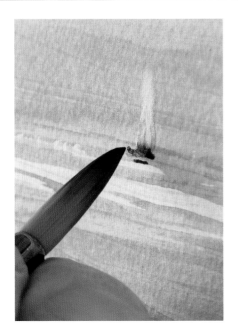

14 Use a mix of ultramarine blue and burnt sienna to dot a dark colour under the lifted-out area of light for the boat. Allow to dry – make sure that the whole painting is dry before you start work on the headland.

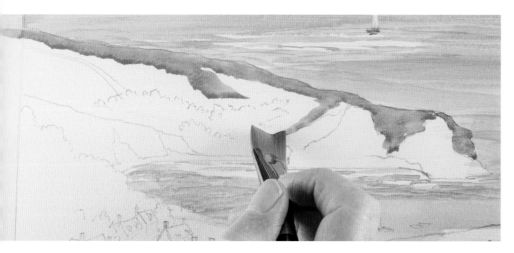

15 With the small flat wash brush and a mix of Hooker's green and yellow ochre, lay a wash of grass on top of the headland. Use the corner of the brush to work carefully around the edges – as with the hills, make your brushstrokes count over the headland to determine the slope of the land.

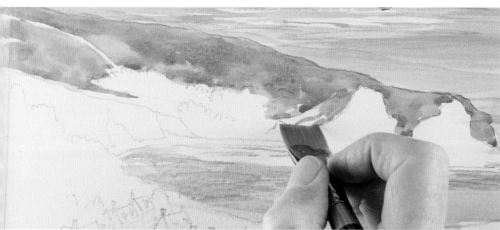

16 Add a little more yellow ochre to the mix to lighten the grass in a few places.

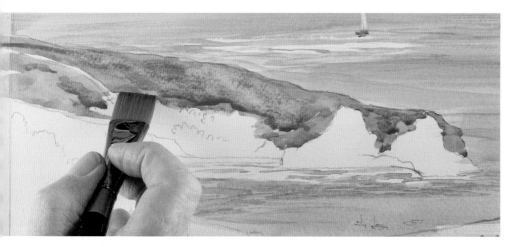

17 Put in a touch of light red – with plenty of water – in amongst the grasses. This, again, gives variation in the colours of the grasses. Soften down the reds with a clean, damp brush – you will see lots of different colours at play. While the grassy areas are still wet, move around the colour here and there.

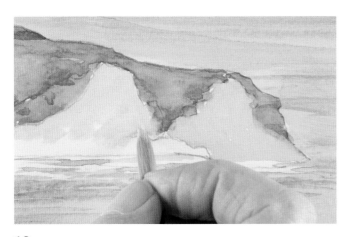

18 Change to the size 8 round brush and begin to create the cliff itself beneath the grasses using Sand.

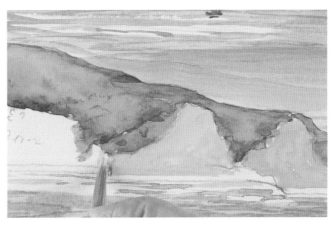

19 Put in more grass at the base of the cliff in the Hooker's green–yellow ochre mix from step 15.

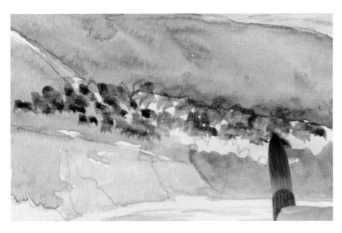

20 Still using the size 8 brush, mix Hooker's green and burnt sienna for a cluster of distant trees and bushes on the headland. Dot these trees in as simple blobs with the tip of your brush to build up the idea of foliage without going into too much detail.

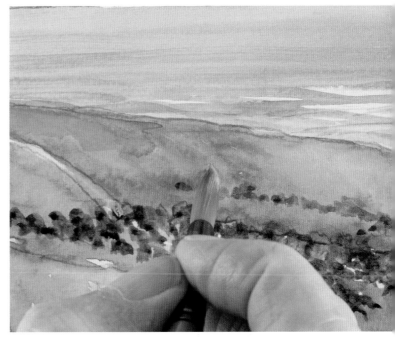

21 Now begin to put in some light into the clifftops. Take up a little cadmium yellow hue gouache and run a few light areas across the top of the headland. Drag the colour diagonally downwards to shape the land with light.

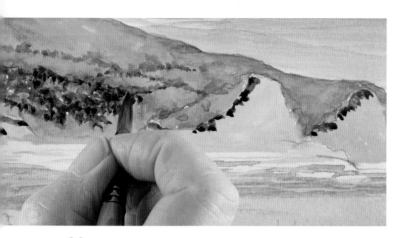 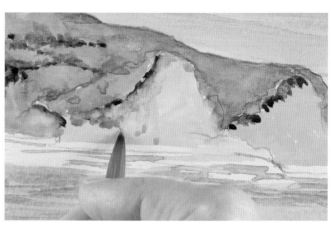

22 Contrast the lights with darks – mix ultramarine blue, alizarin crimson and burnt sienna and put in a fairly strong, dark line of shadow mix under where the grass overhangs the cliffs, and dot in areas of shadow among the trees.

23 Soften the darks with a clean, damp brush and move the shadow around slightly. Use darks to separate the hills at the tip of the headland.

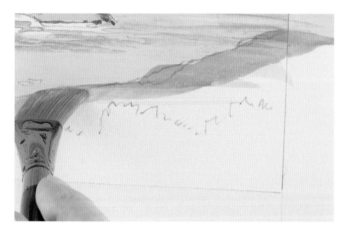

24 Move over to work on the land on the right-hand side of the painting. With cadmium yellow hue gouache on the large flat brush, put in a swathe of light coming down the hill. Again, use your brushstrokes to shape the land.

25 Put in a touch of Hooker's green and yellow ochre mix for a bright green over the top of the gouache.

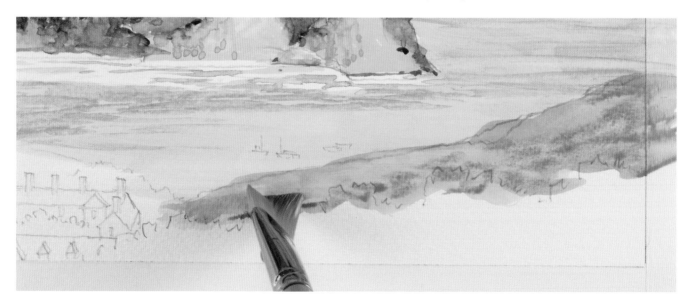

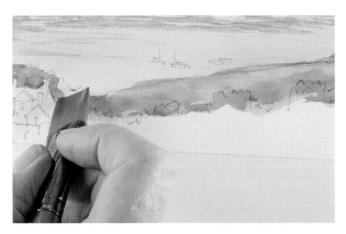

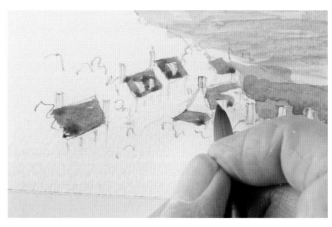

26 Use the Hooker's green–yellow ochre mix to put in some colour in and around the houses on the left of the scene. Use the corner of the flat brush for this level of detail as you can be very precise. Leave this area to dry before you start on the houses themselves at the next step.

27 The houses themselves are white, with burnt sienna roofs, which you can block in using the tip of the size 8 round brush. The angle of these roofs is important as you are looking down on them – the roof lines will appear to go upwards. Work carefully around the gable windows.

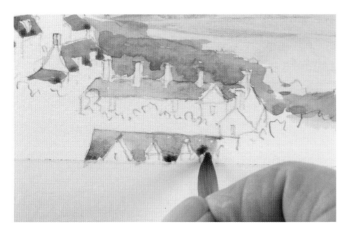

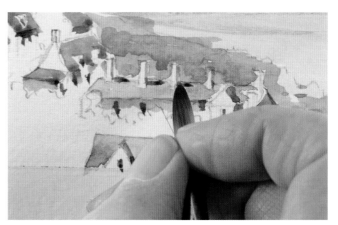

28 Mix ultramarine blue and light red for the warm, slate grey of the roofs in the foreground. Strengthen the mix for the areas next to the gable windows as these will cast shadows on the roof.

29 Mix ultramarine blue and burnt sienna and stroke in the windows of the buildings. With a shadow mix of ultramarine blue, alizarin crimson and burnt sienna, put in shadows on the right-hand sides of the chimneys, and on the roofs where the chimneys cast shadows.

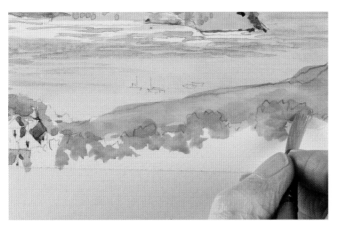

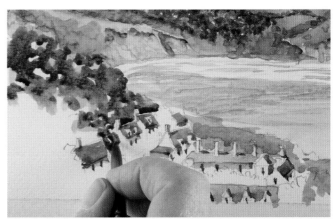

30 Begin to stipple in more trees along the foreground and between the rows of houses with the size 8 round brush loaded with yellow ochre. Strengthen the yellow ochre slightly for the trees leading up to the right-hand hills. Then tap in the yellow over the tops of the trees.

31 Make up a strong mix of Hooker's green and burnt sienna, and tap the colour over the yellow ochre of the trees, leaving some yellow visible here and there. Work carefully around the houses – the trees behind the houses will help accentuate the buildings and push them forwards in the scene.

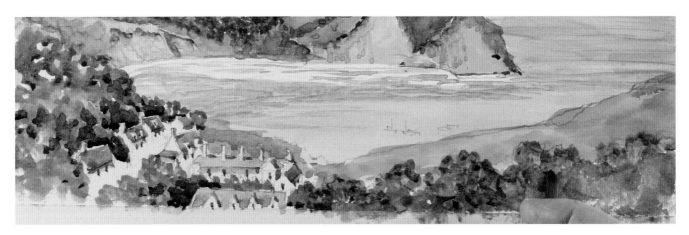

32 Put in a few touches of ultramarine blue on its own, especially into the trees where they meet the houses, as this will help bring out the buildings more. Work across the foreground and dot in the blue among the trees on the right-hand side.

33 Paint in the tiny boats moored in the cove. For two of the boats, block in the hulls in alizarin crimson with the tip of your size 8 round brush. Block in one of the other boats in cobalt blue and the other in Hooker's green. Finally, dot in the details of the boats – including the masts – with the tip of the brush and an ultramarine blue–burnt sienna mix.

Charlie's top tip: painting non-natural objects

While I advise against changing blues for natural aspects of the landscape – such as the sky, the sea and shadow mixes – it is fine to switch to a different blue for a 'non-natural' object, such as a blue boat in the scene. In this case, the use of a different blue in the scene will make the object stand out.

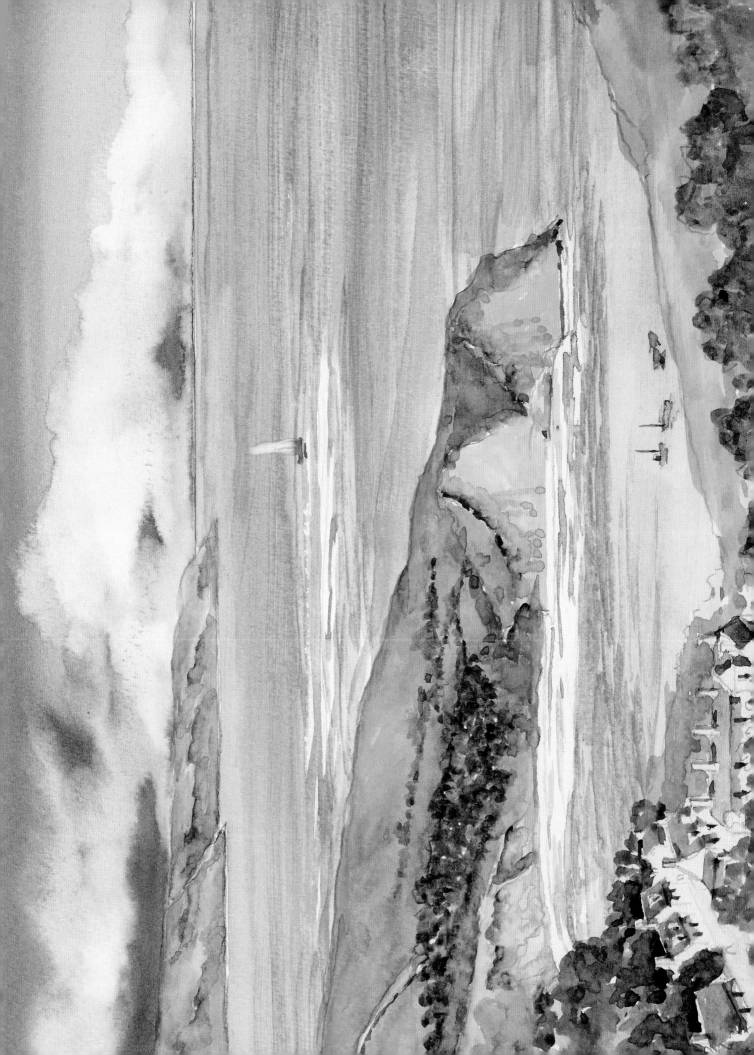

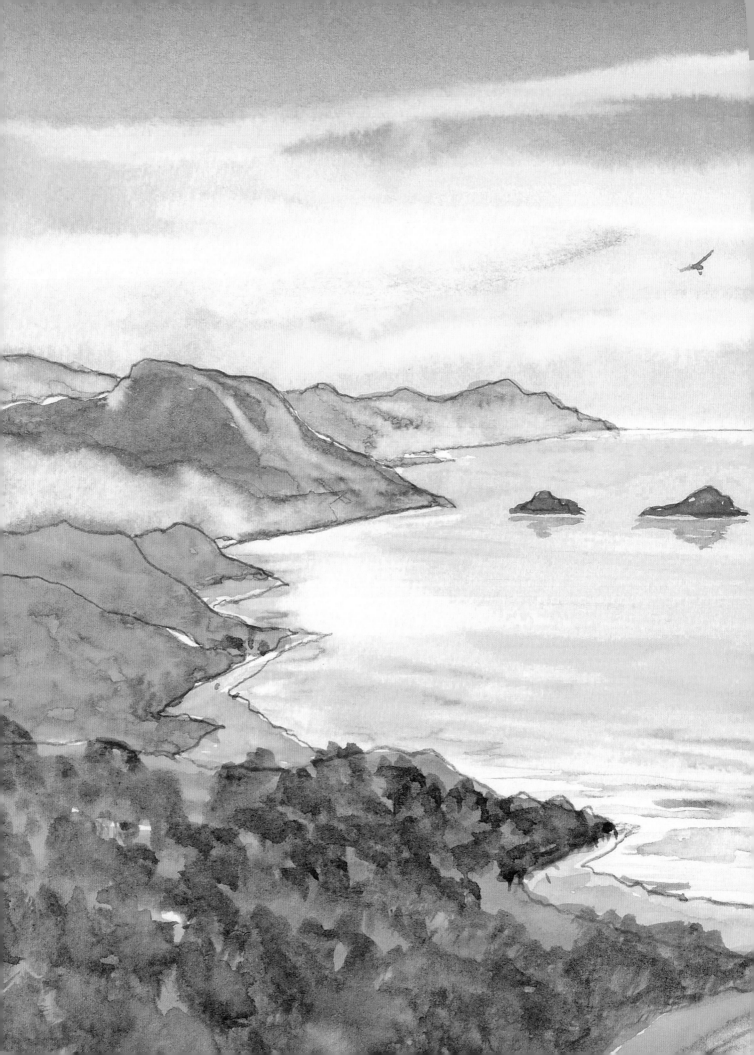

Project 3: *Warm Climes*, pages 46–57.

THE OUTLINES

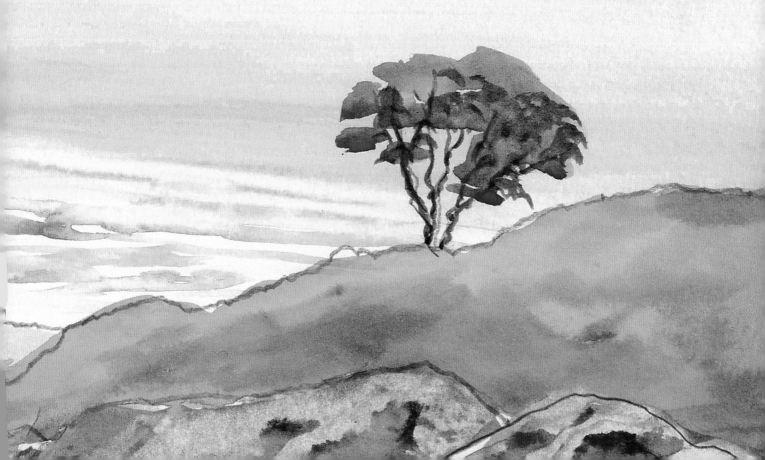

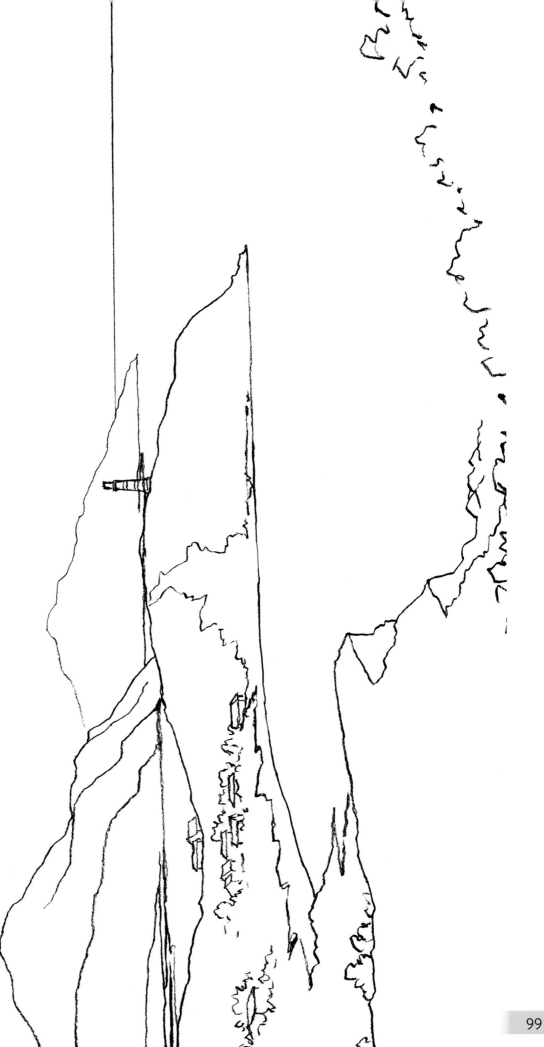

2

3

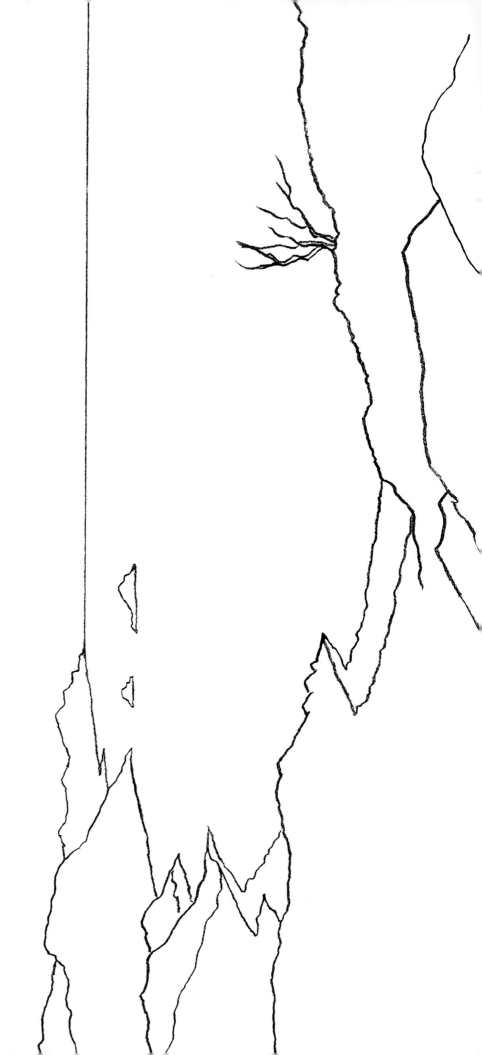

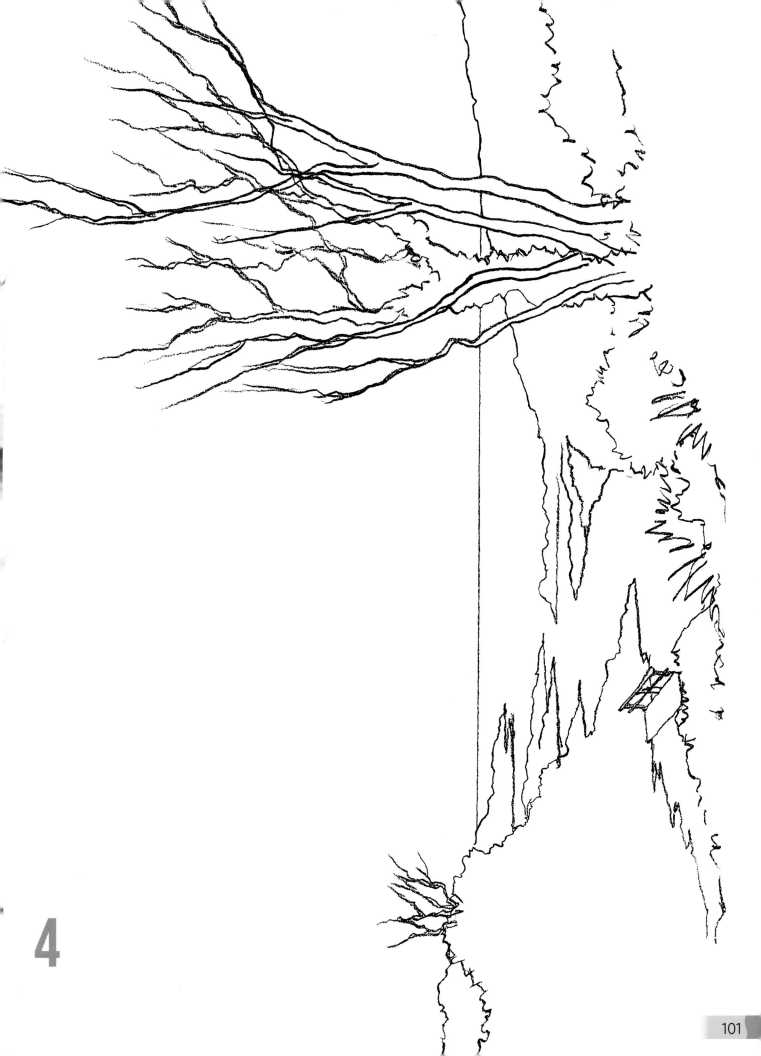

4

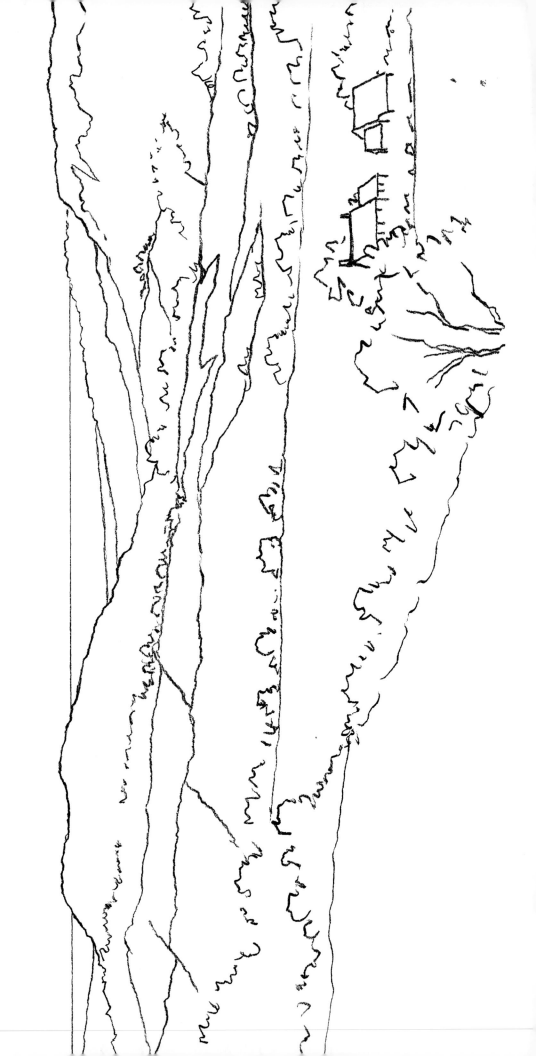

6

INDEX